MangaMatrix
マンガマトリックス

Create Unique Characters Using the Japanese Matrix System

Hiroyoshi Tsukamoto

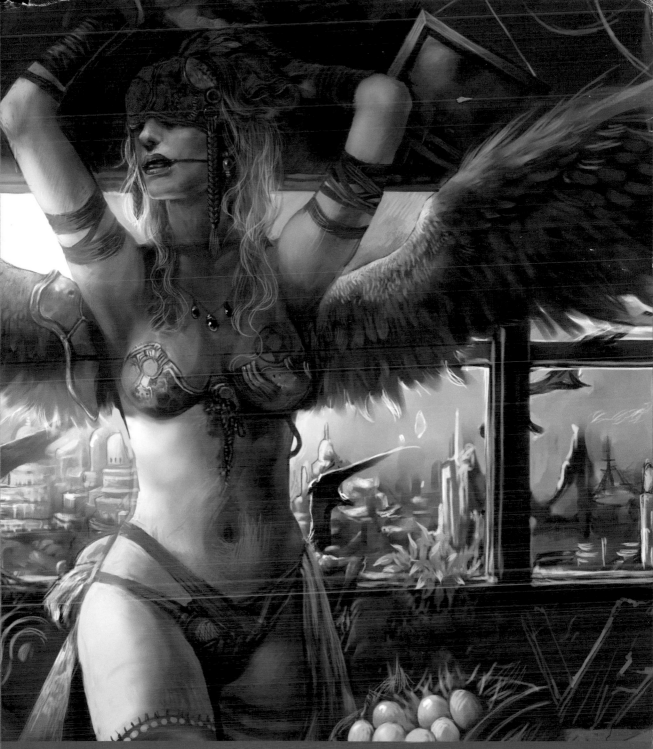

MangaMatrix
マンガマトリックス

Create Unique Characters Using the Japanese Matrix System

Hiroyoshi Tsukamoto

COLLINS DESIGN
An Imprint of HarperCollinsPublishers

MANGA MATRIX: CREATE UNIQUE CHARACTERS USING THE JAPANESE MATRIX SYSTEM

HarperCollins books may be purchased for educational, business, or sales promotional use.
For information, please write: Special Markets Department, HarperCollins Publishers,
10 East 53rd Street, New York, NY 10022.

Originally published in 2004 under the title as:
CHARACTER MATRIX written and supervised by Hiroyoshi Tsukamoto
Copyright © Hiroyoshi Tukamoto, 2004
All rights reserved.
Original Japanese edition published by Maar-sha Publishing Company LTD.

This English edition published by arrangement with Maar-sha Publishing Company LTD., Tokyo
in care of Tuttle-Mori Agency, Inc., Tokyo, Japan

First English edition published in 2006 by:
Collins Design
An Imprint of HarperCollins*Publishers*
10 East 53rd Street
New York, NY 10022
Tel: (212) 207-7000
Fax: (212) 207-7654
collinsdesign@harpercollins.com
www.harpercollins.com

Distributed throughout the world except Japan by:
HarperCollins*Publishers*
10 East 53rd Street
New York, NY 10022
Fax: (212) 207-7654

English translation: Seishi Maruyama, Alma Reyes-Umemoto (ricorico)
Copy-editing: Alma Reyes-Umemoto (ricorico)
Book Design and Art Direction: Eiko Nishida (cooltiger ltd.)
Chief Editor and Production: Rico Komanoya (ricorico)

Library of Congress Control Number: 2006921117

ISBN: 978-0-06-089341-5

Printed in China by Everbest Printing Co., Ltd.
Fourth Printing, 2009

CONTENTS

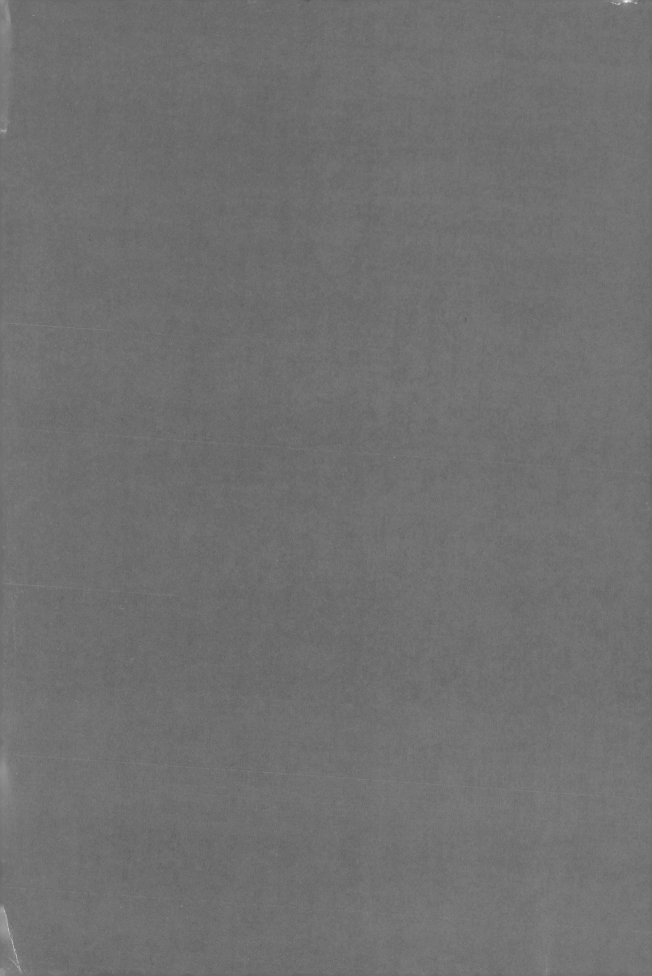

Half-human creatures and multiformed
beasts are concrete forms of
our wishes and desires.

What character do you desire?

Limitless characters can be formed by dividing all existing elements in this earth
into parts, converting them into symbols, and arranging them in a matrix diagram.
Finally, the dream character you desire can be fulfilled!

Half-human Creatures

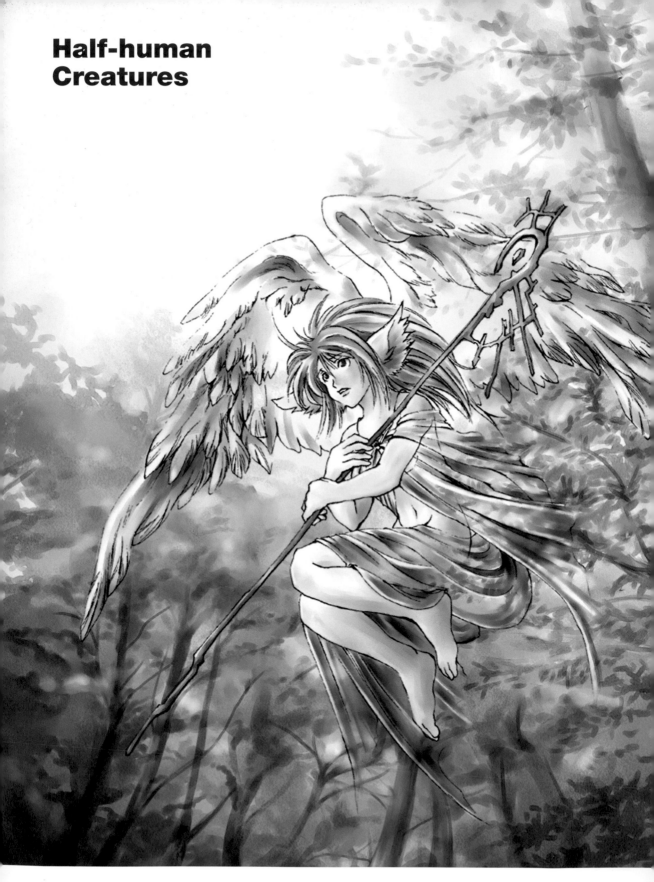

These creatures desire to be unique, possess special abilities, love, be loved, and protect.

Complex forms combined from humans and other beings, then later generalized, are called half-human creatures.

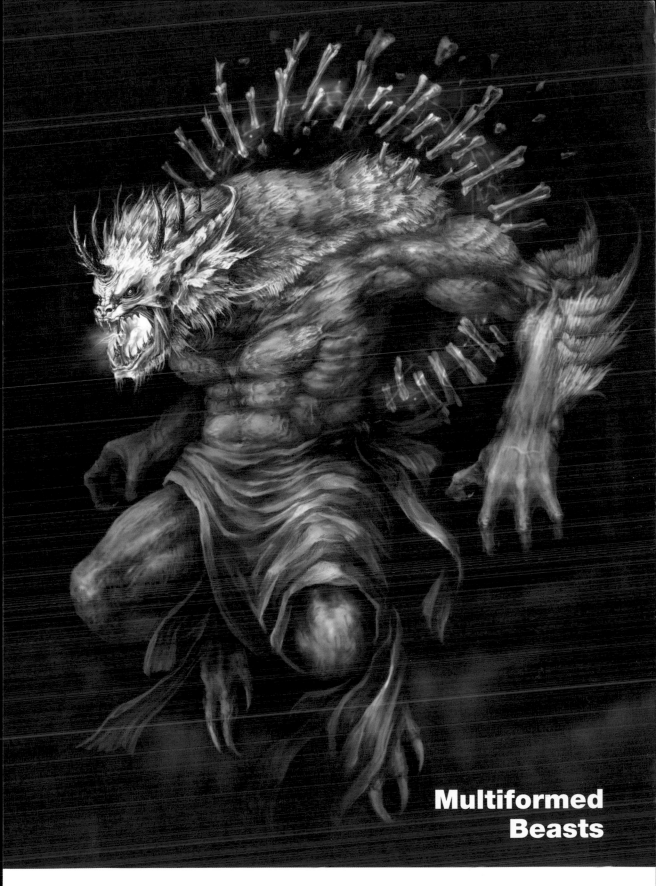

Multiformed Beasts

These beasts want to be mega powerful, omnipotent, and to control, be controlled, destroy, and be destroyed.

Complex forms that are combined from various types of living creatures, and later generalized, are called multiformed beasts. They are born with much more strength than fellow powerful combined beings.

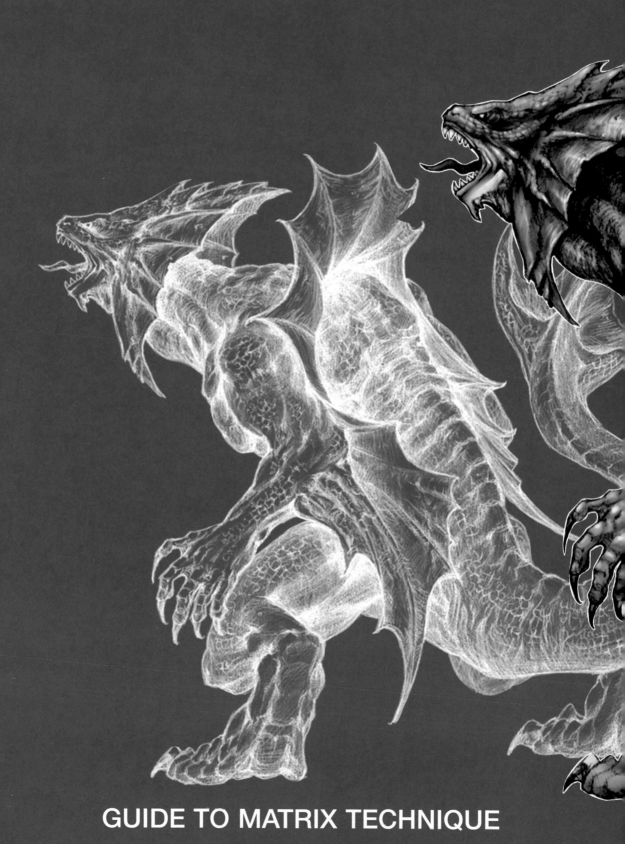

GUIDE TO MATRIX TECHNIQUE

WHAT IS THE MATRIX?

This book introduces the method of using the matrix technique to create new types of half-human characters and multiformed beasts. The word "matrix" can mean many things:

-n. (pl. ma•trices): mother, base; (cell biology) cell quality; (earth science) foundation; (printing) print type, paper maché mold; (recording) master record; (ore) mother rock; (math) matrix; (computer) matrix/input and output electrical cord, matrix display, matrix printer, matrix storage; (language) matrix sentence; and matrix mechanics.

In this book, "matrix" refers to the mathematical method used for character making.

"Matrix" in mathematics is defined as the rectangular layout of several numbers or letters, which are arranged in a table of rows and columns. All elements in space can be used to create characters by converting them into symbols and laying them out in rows and columns. By plotting the cross section of the elements, half-human creatures and multiformed beasts can be created. The elements and their order of arrangement can be combined infinitely to further produce possible results. Creating from nothing can be difficult, no matter how crafty a creator is. However, with the matrix method, characters can be created limitlessly, beyond one's imagination.

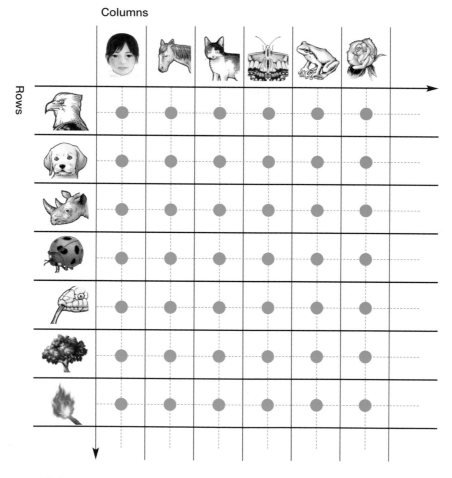

All elements can be converted into symbols to create infinite characters.

FORM x COSTUME x PERSONALITY = INFINITY

Method of Infinite Character Making

1. Form Matrix (limitless forms) – p. 14

Form refers to the character's bodily structure and shape. All elements on this earth can be used as materials to form the character's body. Combining the parts of those elements can create new types of living creatures. Objects that don't exist in the real world, like a moving castle or an object that talks are all possible.

2. Costume Matrix (limitless costumes) – p. 28

Once the character's body is formed, he can be thought of as newly born child. He can wear any dress or hold any object.

3. Personality Matrix (limitless personalities) – p. 30

Since the formed character is visionary, he has no fixed personality. He is as blank as a sheet of white paper, and you can dictate his personality freely, beyond the limits of your imagination. Anything goes.

Carp

It is a ferocious animal that accompanies the rabbit warrior. Like the rabbit warrior, its form can change. It is huge and attacks any object that it does not recognize. It never sleeps and eats grass, humans-all kinds of things. It disappears when the fire in its body is exhausted.

Sample Creation:

Step 1. ○ Form
Combination beast: carp x fire
Half-human creature: rabbit x warrior

Step 2. ☆ Costume
Rabbit warrior design
The armor is powerful and is combined with claws. The helmet is adorned by rabbit symbols, such as the image of the moon in the shape of a moon and a cloud.

Step 3. ❏ Personality
Rabbit warrior
Rabbit mates look upon him as a "rabbit shogun." When the rabbits are attacked, he becomes their savior. His form may change and he pursues ferocious animals that no one else can handle. Every fifth of May, the ferocious animals become carps, and he takes on the rank of an armored warrior. When the corners of his helmet are folded, he disappears. He dislikes cowardly acts. He has kind feelings and does not believe in the wasteful destruction of life. He does not aggressively pursue the enemy. He sleeps four hours a day, and eats all kinds of things.

(Refer to this legend from p. 37 and onwards: ○ =Form, ☆ =Costume, ❏ =Personality)

STEPS IN CHARACTER MAKING

1 Form Matrix (p. 16)
Creating the Body Form

Gorilla 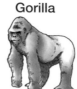 + Rock

Form Table

- **Fixed form**
- **Non-fixed form**
- (**Collective form**)
- **Mechanical form**
- **Cracked form**
- **Increase/decrease**
- **Length span**
- **Growth**
- (**Combination**)

	Human being	Doll	Mammal	Fowl	Reptile	Amphibian	Fish	Insect	Plant	Machine	Building	Tool	Other elements
Human being													
Doll													
Mammal													
Fowl													
Reptile													
Amphibian													
Fish													
Insect													
Plant													
Machine													
Building													
Tool													
Other elements			◯										

(Mammal) **Gorilla x** (Element) **Rock**

2 Costume Matrix (p. 30)
Creating the Body Form

Dress-up table

- **Body wear**
- **Covering/footwear**
- **Ornament**
- (**Makeup**)
- **Wrap/tie**
- **Carry-on item**

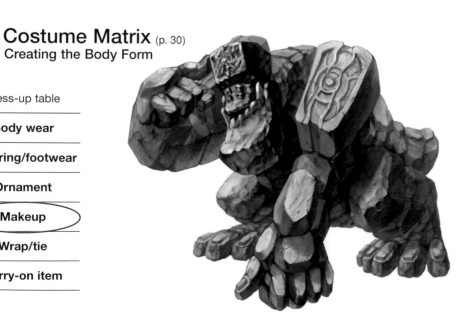

(Makeup) **Sculpture**

3 ## Personality Matrix (p. 32)
Birth of Life

Personality Hexagon

Special attributes
Prone to body attack, possesses Herculean power, stubborn

Behavor
Cheerful, friendly, powerfully just, lonely

Weakness
Swamp

Desire
Friend

Status, profession, position
Forest guardian, justice advocate

Biological environment
Lives in the forest; nocturnal; drinks water

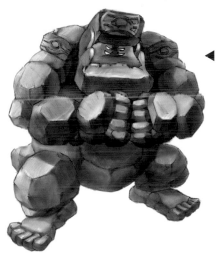

◀ This character is muscular, always cheerful, and possesses a strong sense of justice. It adores small animals and never forgives anyone who disturbs the order of the forest. It defeats its enemies by body attack, using its robust body, made of rock. When it is angry, its power increases to a million horsepower! ▶

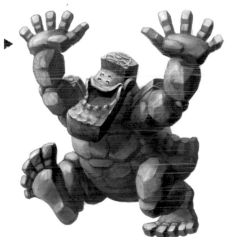

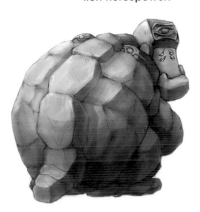

▶ Due to its heavy and rocky body, it would never be able to get out of a swamp if it fell into it. It dislikes the waters because it cannot swim. It easily feels lonely, so it always longs for friends.

15

1 FORM MATRIX

This section covers the study of the structures and shapes of living creatures, which is called morphology. The diagram below shows the table of the human body as it is divided into parts. You can change its body structure with the aid of the form matrix.

Form Table

- Fixed form
- Non-fixed form
- Collective form
- Mechanical form
- Cracked form
- Increase/decrease
- Length span
- Growth
- Combination

Decomposition Diagram for Humans

Human body	Upper body	Head	Face	Eyebrow		Hair
				Eye	eyelash, eyelid, pupil	
				Nose	nostrils	
				Mouth	tooth, fang, tongue	
				forehead, cheek, chin		
			Ear	Earlobe, ear canal		
		Neck				
		Trunk	Shoulder			Back
			Chest	bosom, nipple		
			Abdomen	navel		
		Arm	upper arm, elbow, wrist, back of the hand, palm, finger, fingernail			
	Lower body	Waist				Buttocks
		Leg	thigh, knee, calf, shin, ankle, instep, sole, digit, fingernail, toe, heel			

Fixed form
Normal human shape

Non-fixed form
Combines shapeless elements, such as sand and ice

Collective form
Created from the collection and structure of extraneous elements, such as vines and roots

Mechanical form
Formed from machine body parts

Cracked form
Cracks up body parts

Increase/decrease
Multiplies or decreases the number of body parts

Length span
Lengthens or shortens body parts

Growth
Grows extraneous elements from body parts

Combination
Combines a body part with another creature's body part

Creation of Half-human Characters

You can create a half-human character by combining either a body part from a different creature, or some extraneous components with the human body.

Form Table
Fixed form
Non-fixed form
Collective form
Mechanical form
Cracked form
Increase/decrease
Length span
Growth
Combination

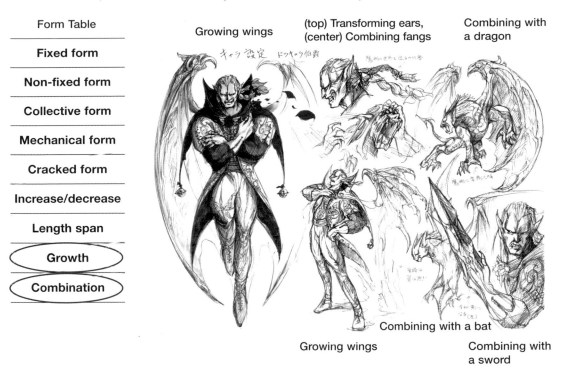

Growing wings

(top) Transforming ears, (center) Combining fangs

Combining with a dragon

Combining with a bat

Growing wings

Combining with a sword

Creation of Multiformed Beasts

A multiformed beast can be created by combining the bodies of different types of animals with extraneous components. You can also personify a lifeless object or combine it as a component of a character.

Form Table
Fixed form
Non-fixed form
Collective form
Mechanical form
Cracked form
Increase/decrease
Length span
Growth
Combination

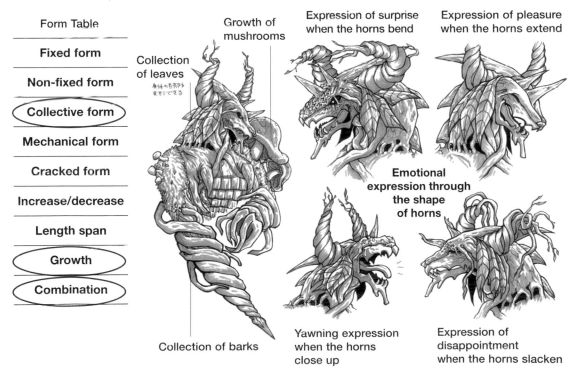

Collection of leaves

Growth of mushrooms

Expression of surprise when the horns bend

Expression of pleasure when the horns extend

Emotional expression through the shape of horns

Collection of barks

Yawning expression when the horns close up

Expression of disappointment when the horns slacken

Combination Diagram 1: Type x Type

Columns: Body Types for Base Structure

Rows: Combined Body Parts

	Human being	Doll	Mammal	Fowl	Reptile	Amphibian	Fish	Insect	Plant	Machine	Building	Tool	Other elements
Human being													
Doll													
Mammal													
Fowl													
Reptile													
Amphibian													
Fish													
Insect													
Plant													
Machine													
Building													
Tool													
Other elements													

All elements that exist in the universe can be listed in a table by categories in rows and columns, intersected and combined to create the body of a character. You can choose and combine the items in the table, as shown, to create a unique creature.

Example:
Human being (column) x Mammal (row)
The human body is used as a base to combine with a body part of a mammal.

Mammal (column) x Human being (row)
The mammal's body is used as a base to combine with a body part of a human being. You can also personify the creature.

This table lists the classified items that exist in the universe, which are often used as base structures for characters. Items that are not listed here can also be used.

Human being	male, female, baby, infant, child, adolescent, middle age, elderly
Doll	clown, Japanese *dharma* doll, Japanese *kokeshi* doll, straw figure, scarecrow, stuffed toy
Mammal	dog, cat, rabbit, monkey, mouse, squirrel, fox, raccoon, weasel, bear, panda, pig, elephant, giraffe, horse, cow, sheep, goat, camel, antelope, deer, reindeer, wolf, hyena, tiger, leopard, lion, bat, kangaroo, koala, flying squirrel, sloth, mole, hedgehog, anteater, armadillo, hippopotamus, rhinoceros, raccoon, seal, sea lion, eared seal, dolphin, whale
Fowl	eagle, hawk, swan, dove, ostrich, crow, owl, chicken, sparrow, gull, penguin, pheasant, duck, pelican, peacock, flamingo
Reptile/ amphibian	snake, cobra, viper, lizard, iguana, gecko, chameleon, tortoise, soft-shelled turtle, alligator, crocodile, frog, salamander
Fish/aquatic creature	shark, eel, salmon, carp, angler fish, catfish, blowfish, goldfish, tropical fish, squid, crab, crayfish, shell, jellyfish, urchin, seaweed, coral
Insect/ invertebrate animal	butterfly, bee, dragonfly, cicada, firefly, fly, horsefly, spider, scorpion, ant, grasshopper, cricket, katydid, mantis, stag beetle, gold bug, ladybug, beetle, diving beetle, dung beetle, water strider, snail, earthworm, caterpillar
Plant/fruit/ vegetable	tulip, rose, mushroom, cactus, ivy, moss, carnivorous plant, oak tree, fir tree, beech tree, cherry, plum, willow, cedar, apple, pumpkin
Machine	wiring, gear, clock, television, telephone, computer, train, bus, car, bicycle, airplane, rocket, spaceship, ship, sewing machine
Building	castle, tower, windmill, clock tower, apartment, house, skyscraper, spiral staircase, factory, school, station
Tool	arm (shield, saber, sword, knife, bow, spear, gun, ax, sickle, chain, rope, bomb); musical instrument (piano, organ, guitar, violin, Japanese koto, flute, ocarina, harmonica, drum); medical instrument (syringe, stethoscope, scalpel, chart, medicine, crutch); carpentry tool (hammer, screw, nail, saw); stationery (pencil, eraser, ruler, compass, stapler, notebook, scissors, glue); toy (cards, magic kit); toiletry (mirror, compact, lipstick); sewing kit (needle, thread, button); witchcraft tool (cane, talisman, witch book); cookware (kitchen knife, frying pan, pot, dish, knife, fork); personal belonging (cigarette, umbrella, bag, wallet)
Other elements	sky, moon, star, sun, earth, air, cloud, rainbow, rain, thunder, wind, fire, water, ice, snow, dirt, sand, rock, stone, smoke, electricity, gold, silver, copper, iron, nylon, plastic

Creation of Half-human Creatures

(Amphibian) (Human being) (Created part)
Frog x Man + Claw + Gills

This creature has a frog's body as the base, combined with webs and gills to create a fish-human hybrid.

	Human being	Doll	Mammal	Fowl	Reptile	Amphibian	Fish	Insect	Plant	Machine	Building	Tool	Other elements
Human being						◯							
Doll													
Mammal													
Fowl													
Reptile													
Amphibian													
Fish													
Insect													
Plant													
Machine													
Building													
Tool													
Other elements													

Creation of a Multiformed Beast

(Insect) (Created part)
Spider x Beetle + Claw ı Eyes

This creature is designed by combining a spider's body as its base with a transformed beetle's horn. The claws and eyes are combined.

	Human being	Doll	Mammal	Fowl	Reptile	Amphibian	Fish	Insect	Plant	Machine	Building	Tool	Other elements
Human being													
Doll													
Mammal													
Fowl													
Reptile													
Amphibian													
Fish													
Insect								◯					
Plant													
Machine													
Building													
Tool													
Other elements													

Combination Diagram 2: Type x Parts

Columns

Rows

	Human being	Doll	Mammal	Fowl	Reptile	Amphibian	Fish	Insect	Plant	Machine	Building	Tool	
Horn													
Ear													
Eye													
Fang													
Tongue													
Wings													
Tail													
Claw													
Skin													
Scissors													

Using the same table as the Combination Diagram 1, list the different types of bodies in columns and the decomposed parts in rows, then intersect and combine them to create the body of a character. The decomposed parts listed here are often used for character making. Any other preferred item can also be added.

Horn	antelope, deer, reindeer, rhinoceros, sheep, goat, cow, buffalo
Ear	dog, cat, rabbit, fox, wolf, panda, mouse, bat
Eye	dog, cat, rabbit, snake, tortoise, frog, eagle
Fang	dog, cat, wolf, alligator
Tongue	snake, giraffe, chameleon, cat
Wings	swan, eagle, hawk, owl, bat, butterfly, dragonfly, grasshopper
Tail	dog, cat, rabbit, fox, bear, mouse, alligator, lizard, whale
Claw	dog, cat, eagle, lizard, tortoise, bear, tiger
Skin	snake, alligator, bear, tiger, zebra
Scissors	crab, crayfish, shrimp, stag beetle, grasshopper

This table lists the creatures that exist in the universe, which are often used as base structures for characters. Their individual parts are listed in the first column. As in the Combination Diagram 1, items that are not listed here can also be used.

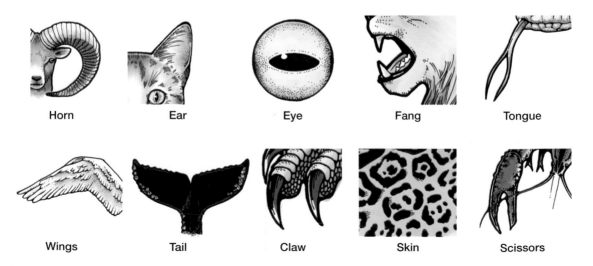

Horn	Ear	Eye	Fang	Tongue

Wings	Tail	Claw	Skin	Scissors

Creation of Half-human Creatures

(Human being) (Crayfish)
Beautiful woman + Scissors + Skin

	Human being	Doll	Mammal	Fowl	Reptile	Amphibian	Fish	Insect	Plant	Machine	Building	Tool
Horn												
Ear												
Eye												
Fang												
Tongue												
Wings												
Tail												
Claw												
Skin	O											
Scissors	O											

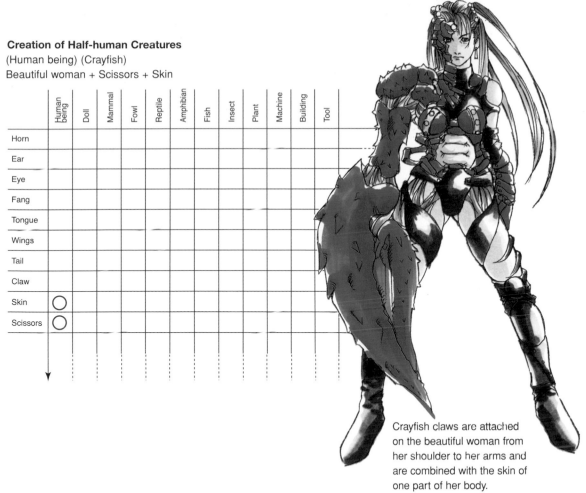

Crayfish claws are attached on the beautiful woman from her shoulder to her arms and are combined with the skin of one part of her body.

Creation of a Multiformed Beast

(Created part)
Buffalo + Horns + Tail + Claw + Skin + Scissors

	Human being	Doll	Mammal	Fowl	Reptile	Amphibian	Fish	Insect	Plant	Machine	Building	Tool
Horn			O									
Ear												
Eye												
Fang												
Tongue												
Wings												
Tail			O									
Claw			O									
Skin			O									
Scissors			O									

The buffalo is used as a base structure to create a beast, which is then combined with horns, claws, skin, and scissors.

Combination of Different Parts

In our minds, we have a stereotyped belief that a certain type of animal has fixed body parts. For example, we believe that the bull's horn is found on the bull's head and the cat's eyes belong to the cat's face. However, a character is an imaginary creature; hence, it is not necessary to follow the standard animal physiology. One can choose and combine as many different types of body parts as desired.

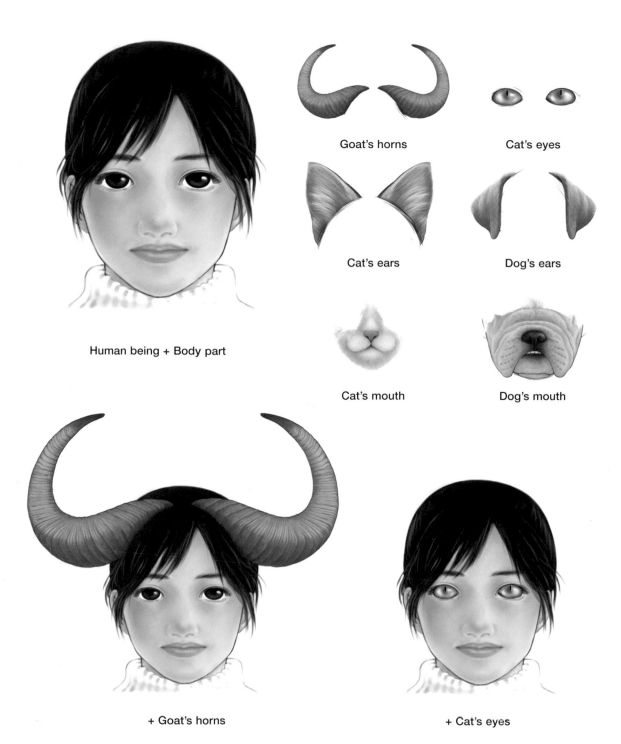

Human being + Body part

Goat's horns

Cat's eyes

Cat's ears

Dog's ears

Cat's mouth

Dog's mouth

+ Goat's horns

+ Cat's eyes

+ Cat's ears

+ Dog's ears

+ Cat's mouth

+ Dog's mouth

+ Goat's horns + cat's mouth

+ Cat's eyss + dog's ears

We believe that the angel's wings are fixed at the back. However, as we have seen on p. 22, a character is an imaginary creature; hence, one can position body parts wherever one wishes. In creating angels, one can also choose any kind of wings and attach them from head to toe.

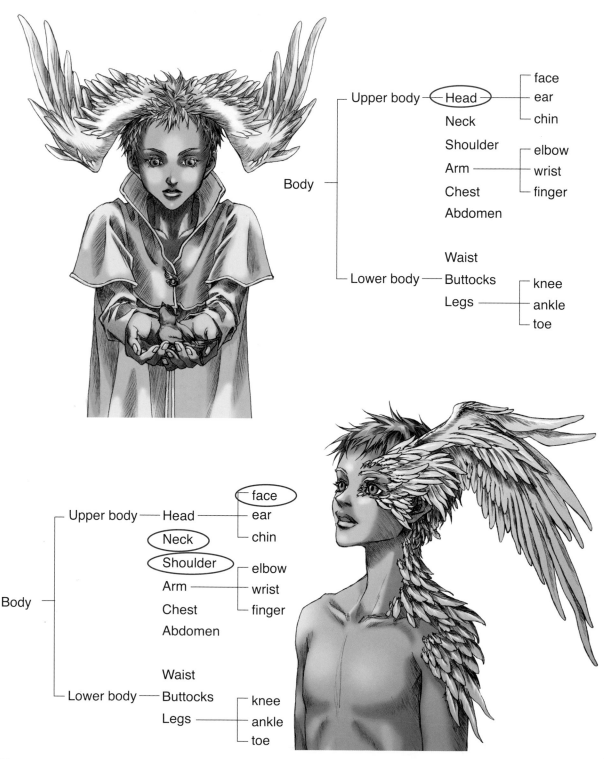

```
                                      ┌ face
                    ┌ Head ───────────┼ ear
        Upper body ─┤  (Head circled) └ chin
                    │ Neck
                    │ Shoulder         ┌ elbow
Body ───────────────┤ Arm ────────────┼ wrist
                    │ Chest            └ finger
                    │ Abdomen
                    │
                    │ Waist
        Lower body ─┤ Buttocks         ┌ knee
                      Legs ───────────┼ ankle
                                       └ toe
```

```
                                      ┌ face (circled)
                    ┌ Upper body ─ Head ─┼ ear
                    │                    └ chin
                    │ Neck (circled)
                    │ Shoulder (circled) ┌ elbow
Body ───────────────┤ Arm ──────────────┼ wrist
                    │ Chest              └ finger
                    │ Abdomen
                    │
                    │ Waist
                    └ Lower body ─ Buttocks ┌ knee
                                    Legs ───┼ ankle
                                            └ toe
```

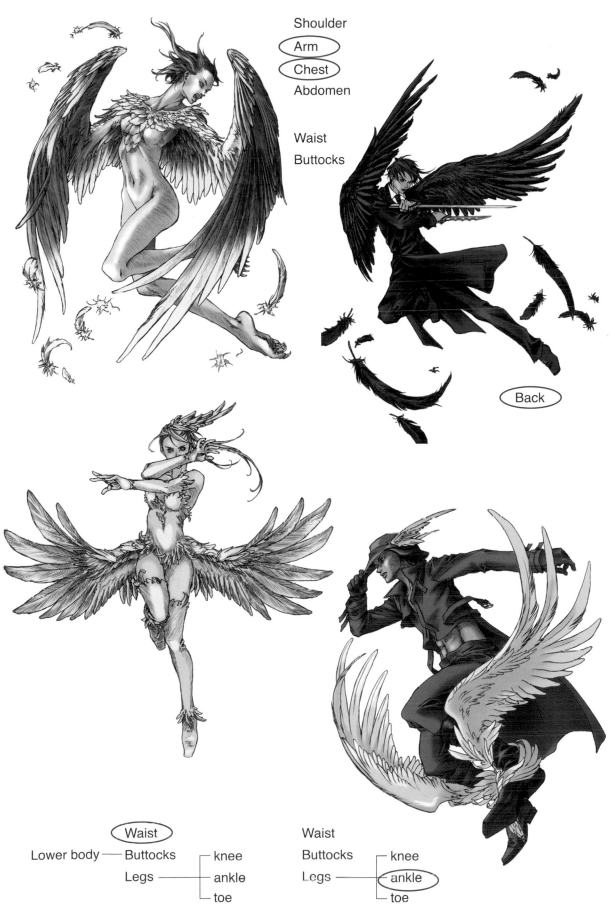

Shoulder

(Arm)

(Chest)

Abdomen

Waist

Buttocks

(Back)

(Waist)

Lower body — Buttocks ⌐ knee

Legs ⌐ ankle

⌐ toe

Waist

Buttocks ⌐ knee

Legs ⌐ (ankle)

⌐ toe

To create original multiformed beasts with deformed bodies, one can develop a rough design first, and later gradually change its form. The sample designs below demonstrate the key to the transformation of monsters.

■ Draft of first form

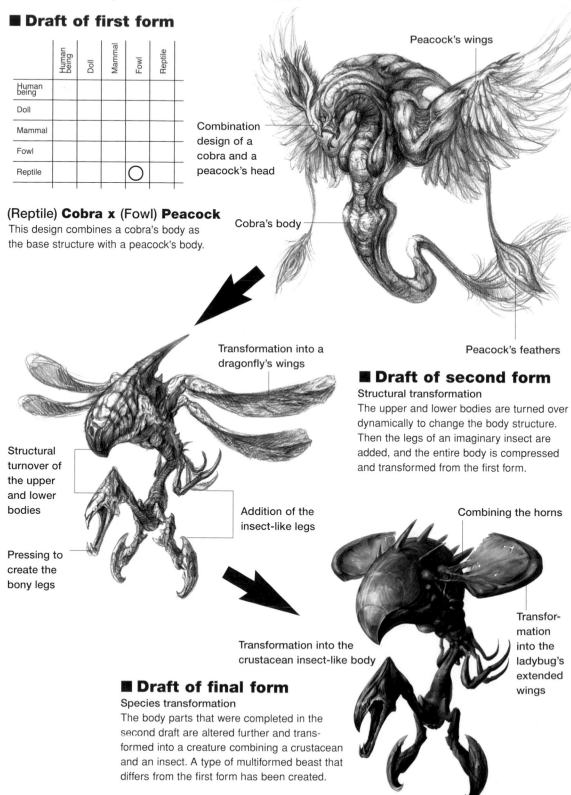

	Human being	Doll	Mammal	Fowl	Reptile
Human being					
Doll					
Mammal					
Fowl					
Reptile				○	

(Reptile) Cobra x (Fowl) Peacock
This design combines a cobra's body as the base structure with a peacock's body.

Peacock's wings

Combination design of a cobra and a peacock's head

Cobra's body

Peacock's feathers

Transformation into a dragonfly's wings

■ Draft of second form
Structural transformation
The upper and lower bodies are turned over dynamically to change the body structure. Then the legs of an imaginary insect are added, and the entire body is compressed and transformed from the first form.

Structural turnover of the upper and lower bodies

Pressing to create the bony legs

Addition of the insect-like legs

Combining the horns

Transformation into the ladybug's extended wings

Transformation into the crustacean insect-like body

■ Draft of final form
Species transformation
The body parts that were completed in the second draft are altered further and transformed into a creature combining a crustacean and an insect. A type of multiformed beast that differs from the first form has been created.

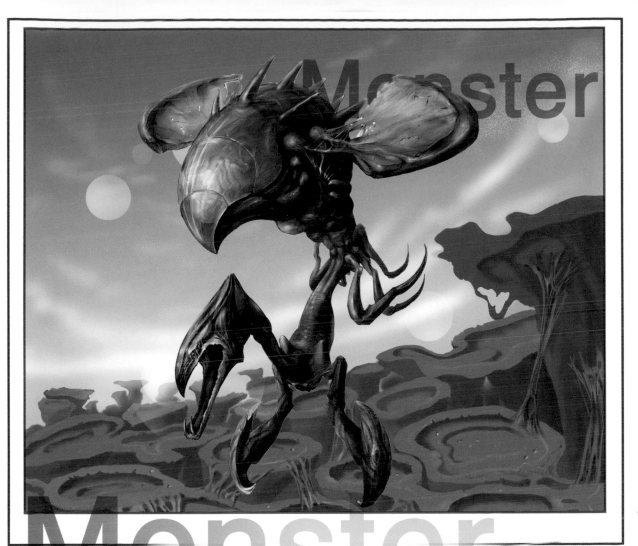

Monster

3m = 10 ft
The creature towers at ten feet.

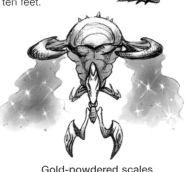

Snaps and attacks
Attacks with the tail

Strange sound
Generally damaged form, and grasps for a voice

Gold-powdered scales
Simple form transforms into a gold nugget.

Continuously scratches

Mixed Types of Rare and Accidental Beasts

The human imagination is limited. It is very difficult to conceive of a creature's body that no one has ever seen before. This section introduces how to create rare creatures by randomly combining the bodies of various kinds of living creatures.

Mammal	Fowl	Reptile/ amphibian	Fish	Insect	Plants/others
cat	owl	tortoise	killifish	fly	tulip
monkey	swallow	snake	goldfish	ladybug	iris
giraffe	swan	lizard	shark	butterfly	rose
dog	ostrich	soft-shelled turtle	carp	ant	ivy
elephant	sparrow	alligator	swordfish	caterpillar	seaweed
bear	chicken	frog	salmon	bee	cactus

First, fill in the table, as illustrated, with the names of as many animals and plants as you can think of, and classify them by their biological categories (i.e. mammal, insect, fish, flower, fowl, reptile, etc.). In the sample table, the names of six animals and plants are listed under six categories.

Next, close your eyes and encircle four or more different animals and plants found on the table. Then, open your eyes. Now, you can create a multiformed beast from the items that you have randomly chosen.

Mammal	Fowl	Reptile/ amphibian	Fish	Insect	Plants/ others
cat	owl	(tortoise)	killifish	fly	(tulip)
monkey	(swallow)	snake	goldfish	ladybug	iris
giraffe	swan	lizard	(shark)	butterfly	rose
dog	ostrich	soft-shelled turtle	carp	ant	ivy
elephant	sparrow	alligator	swordfish	caterpillar	seaweed
bear	chicken	frog	salmon	bee	cactus

**Swallow x Tortoise x Shark x Tulip
(Tortoise's body as base structure)**

Mammal	Fowl	Reptile/ amphibian	Fish	Insect	Plants/ others
cat	owl	tortoise	killifish	fly	(tulip)
monkey	swallow	(snake)	goldfish	ladybug	iris
giraffe	swan	lizard	shark	butterfly	rose
dog	ostrich	(soft-shelled turtle)	carp	ant	ivy
elephant	sparrow	alligator	swordfish	caterpillar	(seaweed)
bear	(chicken)	frog	salmon	bee	cactus

**Chicken x Snake x Soft-shelled turtle x Tulip x Seaweed
(Soft-shelled turtle's body as base structure)**

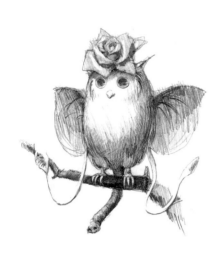

Mammal	Fowl	Reptile/amphibian	Fish	Insect	Plants/others
cat	owl	tortoise	killifish	fly	tulip
monkey	swallow	snake	goldfish	ladybug	iris
giraffe	swan	lizard	shark	butterfly	rose
dog	ostrich	soft-shelled turtle	carp	ant	ivy
elephant	sparrow	alligator	swordfish	caterpillar	seaweed
bear	chicken	frog	salmon	bee	cactus

Elephant x Owl x Snake x Rose
(Owl's body as base structure)

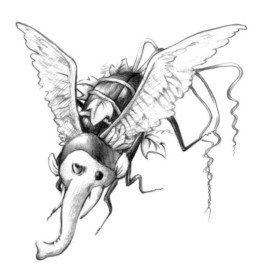

Mammal	Fowl	Reptile/amphibian	Fish	Insect	Plants/others
cat	owl	tortoise	killifish	fly	tulip
monkey	swallow	snake	goldfish	ladybug	iris
giraffe	swan	lizard	shark	butterfly	rose
dog	ostrich	soft-shelled turtle	carp	ant	ivy
elephant	sparrow	alligator	swordfish	caterpillar	seaweed
bear	chicken	frog	salmon	bee	cactus

Elephant x Swan x Fly x Ivy
(Fly's body as base structure)

Mammal	Fowl	Reptile/amphibian	Fish	Insect	Plants/others
cat	owl	tortoise	killifish	fly	tulip
monkey	swallow	snake	goldfish	ladybug	iris
giraffe	swan	lizard	shark	butterfly	rose
dog	ostrich	soft-shelled turtle	carp	ant	ivy
elephant	sparrow	alligator	swordfish	caterpillar	seaweed
bear	chicken	frog	salmon	bee	cactus

Monkey x Chicken x Salmon x Cactus
(Monkey's body as base structure)

Mammal	Fowl	Reptile/amphibian	Fish	Insect	Plants/others
cat	owl	tortoise	killifish	fly	tulip
monkey	swallow	snake	goldfish	ladybug	iris
giraffe	swan	lizard	shark	butterfly	rose
dog	ostrich	soft-shelled turtle	carp	ant	ivy
elephant	sparrow	alligator	swordfish	caterpillar	seaweed
bear	chicken	frog	salmon	bee	cactus

Giraffe x Ostrich x Carp x Cactus
(Ostrich's body as base structure)

2 COSTUME MATRIX

Costumes can express the personality and the body form of the character. By considering the list of forms enumerated in the Form Matrix section (p. 16) and the list of personalities found in the Personality Matrix section (p. 32), one can design a character from head to toe, using any preferred material, color, and design.

Dress-up Table

Body wear

Covering/footwear

Ornament

Makeup

Wrap/tie

Carry-on item

This table shows the classification of costumes and the methods of wearing them.

Body wear	folk costume, uniform, dress, tuxedo, suit, leotard, swimwear
Covering/footwear	mask, eye patch, coif, hat, armor, cloak, glove, shoe, fur, glasses, sunglasses, tights
Ornament	crown, collar, bracelet, ring, nose ring, anklet, pierced earring, necklace, jewel, ribbon, wound, skull
Makeup	lipstick, eye shadow, mascara, manicure, tattoo
Wrap/Tie	bandage, cast, artificial leg, shawl, scarf, rope, chain, turban, bandana, ribbon
Carry-on item	armor (shield, saber, sword, knife, bow, spear, gun, rope, ax, chain, bomb); musical instrument (Japanese koto, flute, ocarina, harmonica); medical instrument (syringe, stethoscope, scalpel, chart, medicine, crutch); stationery (pencil, eraser, ruler, compass, stapler); toy (doll, cards, magic kit); toiletry (compact, lipstick); witchcraft tool (cane, talisman, book); cookware (kitchen knife, frying pan, pot, dish, knife, fork); personal belonging (cigarette, umbrella, bag, cellular phone)

Body Wear
suit

Covering
glove

Ornament
bracelet and ring

Makeup
tattoo

Wrap/Tie
cast

Carry-on item
knife

Heaven	sky, moon, star, sun, cloud, rainbow, rain, wind, thunder
Earth	dirt, sand, rock, stone, tree, leaf, petal, shell, feather, hide, fur, leather, cloth, etc.
Water/fire	drip, snow, ice, flame, smoke
Inorganic matter	gold, silver, copper, iron, nylon, plastic, concrete, fiber
Image	light, darkness

Choice of costume materials
One can choose the elements that constitute the material, color, and shape of the costume from this table.

Body wear

Covering/footwear

Ornament

Makeup

Wrap/tie

Carry-on item

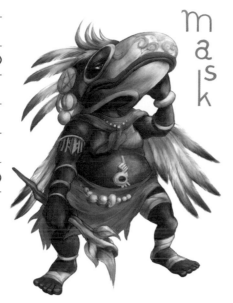

m
a
s
k

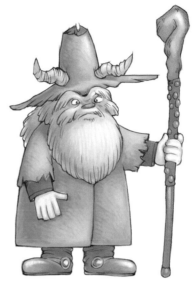

○ primitive man + wings
☆ wooden mask + wooden cane

○ elderly man + horns
☆ cloth hat + wooden cane

Body wear

Covering/footwear

Ornament

Makeup

Wrap/tie

Carry-on item

○ warrior x cow x ax
☆ nose ring, bracelet and waistband

Body wear

Covering/footwear

Ornament

Makeup

Wrap/tie

Carry-on item

○ bark and chain of ivy x warrior
☆ pumpkin-skinned armor,
 copper saber and shield

31

3 PERSONALITY MATRIX

Personality refers to the character's particular behavioral characteristics. In a broad sense, the costume's form and design are parts of the character's personality, since the physical characteristics and the costume attire can determine the character's identity and profession. The six charts illustrated here introduce the necessary personality settings and show the infinite number of form and costume combinations for character making.

Six Personality Classifications

Behavior	angry, cry baby, scared, gloomy, cheerful, optimistic, capricious, shy, arrogant, lonely, hasty, easy-going, timid, devilish, good-natured, ill-natured, serious, cold, delicate, nervous, selfish, arbitrary, impudent, egoistic, rough, ferocious, lecherous, honest, dishonest, cunning, brave, supple, pure, unrestrained, kind, strict, humanistic, hysterical, difficult, frivolous, narcissistic, sadistic, masochistic, romantic, flirtatious	<< Characteristics referring to emotion, will, and character behavior
Status	king, queen, prince, princess, knight, gentleman, lady, billionaire, patriarch, chairperson, army general, nobleman, slave	
Profession	lumberjack, flutist, minstrel, actor/actress, street performer, magician, puppeteer, wizard/witch, fortune teller, dancer, singer, painter, inventor, teacher, student, scholar, doctor, nurse, lawyer, judge, driver, carpenter, bartender, waiter/waitress, shopkeeper (baker, florist, etc.), assassin, terrorist, soldier, ninja, samurai, police officer, hunter, detective	<< Characteristics referring to social position, work qualification, and profession, which can be related to the costume's design
Position	justice advocate, evil mastermind, leader, follower, master, pupil, traveler, pet, president, employee, secretary, merchant, manager, caretaker	

Biological environment	Habitat	mountain, forest, woods, hollow of a tree, nest, cave, desert, soil, river, fountain, lake, canyon, ocean, iceberg, city, underground, spiritual world, heaven, hell, interior of: jar, lamp, gem, crystal ball, mirror, picture, inside doll, dish, precision machinery; fire, water, wind, soil, dream, mind, house (ceiling, wall, closet, drawer, etc.)	<< Characteristics referring to the biological environment, such as the character's habitat, food, and activities
	Activity	nocturnal, diurnal, sleepless, wakes up once in a number of years	
	Food	herbivorous, carnivorous, omnivorous, cannibalistic, eats: anything, love, dream, hope	

Special attributes	flying, diving, speed running, jumping, high-speed movement, Herculean power, virulence, mimicry, petrifaction, reflection, absorption, transformation, possession, deformation, alter ego, fission, fusion, reproduction, recovery, immortality, regeneration, resurrection, hot air, cold air, fire breathing or blowing, wind/fire manipulation, water/soil, human and monster manipulation, ability to talk with animals, vision in the dark, sharp sense of smell, transparency, elasticity, intelligence, singing, dancing, performance, music playing, cooking, hallucination, curse, offensive spell, defensive spell, healing spell, summoning spell, beam, barrier, supernatural power (telepathy, telekinesis, clairvoyance, teleportation, second sight)	<< Characteristics referring to the character's special abilities, such as those of a half-human character or a multi-formed beast that are non-existent in living creatures of this world

Weakness	morning, light, darkness, rain, thunder, smoke, wind, fire, water, sand, ice, dust, hot air, cold air, animal name, food name, man, woman, child, temptation, tears, money, cross, holy water, prayer, noise

<< Qualities referring to a character's weaknesses; a character without a weakness is not interesting.

Desire	love, courage, dream, joy, hope, freedom, pleasure, heart, trust, life value, meaning of life, youth, eternal life, power, wings, friend, lover, family, team mate, beauty, wisdom, intelligence, flesh and blood, food, drink, home, clothes, energy, money, status and honor, hometown, reminiscence, memory

<< Characteristics referring to a kind of longing, like a character quenching its thirst and wanting to obtain something badly; this setting may sometimes cause conflict in a character.

Personality Hexagon

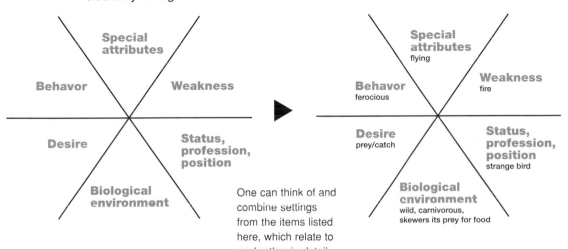

One can think of and combine settings from the items listed here, which relate to each other in detail.

Left hexagon:
Special attributes
Behavor
Weakness
Desire
Status, profession, position
Biological environment

Right hexagon:
Special attributes — flying
Behavor — ferocious
Weakness — fire
Desire — prey/catch
Status, profession, position — strange bird
Biological environment — wild, carnivorous, skewers its prey for food

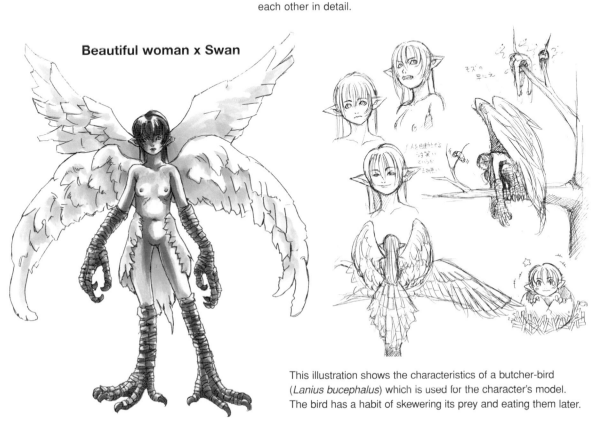

Beautiful woman x Swan

This illustration shows the characteristics of a butcher-bird (*Lanius bucephalus*) which is used for the character's model. The bird has a habit of skewering its prey and eating them later.

FREE CHARACTER CREATION
USING THE MATRIX TECHNIQUE

DESIRE AS THE CREATOR'S MOTIVE POWER

Desire for Existence and Power

Desire to:
be most powerful
be almighty
fly to the sky
dive into the sea
talk to animals
talk to plants
use superpowers
use magic
control the wind
manipulate fire
be brilliant
be beautiful
be charming
be cool
be a hero/heroine
be the best in the world
be the best in the universe
possess a unique existence

Desire for Living Things

Desire to be a:
cat
dog
bird
goat
swan
rose
butterfly
fish
shell
whale
dolphin

Desire for Nature

Desire to be:
wind
a cloud
water
fire
a star
a moon

**Desires in the Presence
of a Living Creature**

Desire to:
be beside it, and put it on one side
control, and be controlled
restrain, and be restrained
love, and be loved
hate, and be hated
play, and be played with
bully, and be bullied
heal, and be healed
injure (someone/something), and
 be injured
kill, and be killed
make someone/something dirty,
 and be dirtied
commit a crime, and be convicted
 of a crime
destroy, and be destroyed
tamper, and be tampered with
care, and be cared for
make fun of (someone/something),
 and be made fun of
tempt, and be tempted
deceive, and be deceived
rear, and be reared
make someone cry
create
know a secret
teach, and be taught
make someone/something a pet
live together
sleep together
travel together
be taken to a different world
catch, and be caught
chase around
get lost
laugh, and be laughed at
to scold, and be scolded
enjoy, and be enjoyed
torture, and be tortured
cause trouble, and be troubled
own, and be owned

KNOWING THE CHARACTER YOU WANT TO CREATE

Creating Your Desired Character

You can create your own desired character by utilizing the matrix diagrams introduced in the previous sections of this book. Come up with ideas for the character image by choosing what type of multiformed beast or half-human character you want to create.

Samples of first impression keywords

pretty, good-looking, beautiful, ugly, dirty, kind, pure, frightening, fearful, ferocious, strong, weak, tender, sexy, cute, cool, easily affected, serious, sharp, fresh, cheerful, active, wild, rational, intelligent, unhealthy, creepy, grotesque, tough, mellow, grave, colorful, gorgeous, poor, elegant, vulgar, good-natured, vicious, holy, ordinary, innocent, childish, young, mature, old, fine, miserable, shady, haughty, dangerous, safe, fierce, tidy, untidy, smelly, aromatic, refreshing, vigorous, tired, noisy

Samples of types of multiformed beasts and half-human characters

God, angel, fallen angel, devil, dragon, fairy/spirit, non-human creature, monster, phantom beast, creatures in the artificial world (cyborg, android, robot), apparition, evil spirit, ghost, alien

Examples of ideas from a desire or wish:

desire to capture a goblin→what type of character is it?→wild young man→flies in the sky→grabs objects with his sharp claws →young man x hawk→non-human creature

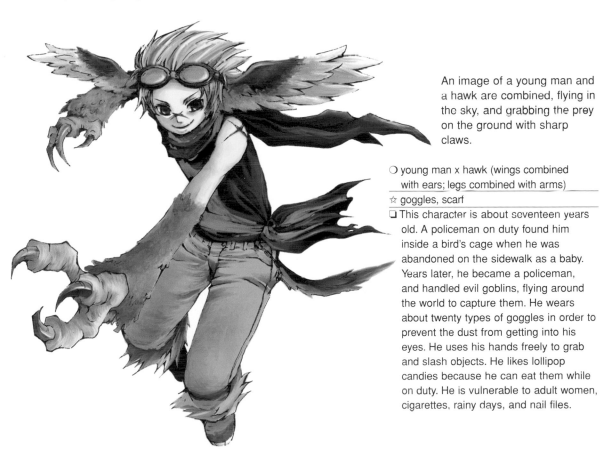

An image of a young man and a hawk are combined, flying in the sky, and grabbing the prey on the ground with sharp claws.

○ young man x hawk (wings combined with ears; legs combined with arms)

☆ goggles, scarf

❏ This character is about seventeen years old. A policeman on duty found him inside a bird's cage when he was abandoned on the sidewalk as a baby. Years later, he became a policeman, and handled evil goblins, flying around the world to capture them. He wears about twenty types of goggles in order to prevent the dust from getting into his eyes. He uses his hands freely to grab and slash objects. He likes lollipop candies because he can eat them while on duty. He is vulnerable to adult women, cigarettes, rainy days, and nail files.

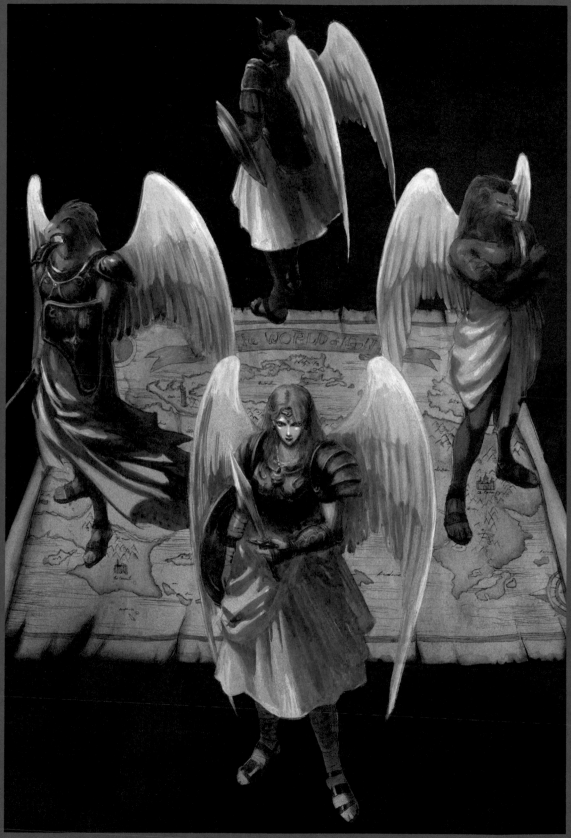

Four guardian deities and beastly gods of the four axes (north, south, east, west), popular in China, here personify angels; east: blue dragon; west: white tiger; south: Emperor Suzaku (mythical peacock-like bird with spread wings); and north: military guardian

Angels

Angels

The basic form of an angel is a beautiful demi-human being with wings on the back and a halo over the head. Angels are said to be neuter, asexual, or hermaphroditic.

The word "angel" originated from the Greek word "angelos," which means a herald or a messenger. It is a demi-human being that serves as a messenger between God and human beings. A hierarchy in the world of angels exists, and the higher classes are closer to the spiritual world and to God. The angels who have the closest relations with the human world are the archangels such as Michael, Raphael, Gabriel, and Uriel. Most angels in the Middle Ages were described as courageous masculine figures dressed in armor with swords in their hands. It was during the Renaissance that the image of angels as beautiful feminine figures or as innocent children began to rise.

Hierarchy of Angels

First class: Seraphim
Second class: Cherubim
Third class: Thrones
Fourth class: Dominions
Fifth class: Virtues
Sixth class: Powers
Seventh class: Principalities
Eighth class: Archangels
Ninth class: Angels

What is Cupid?

Cupid is a naked child with wings. He carries a bow and arrow in one hand. Those who are shot by his golden arrow fall in love, while those who are shot by a metal arrow learn to hate.

Four Archangels of the Eighth Class

Archangel Michael

In the New Testament (John's Apocalypse), Archangel Michael led the battle against the devil Satan and cast him out of heaven. He appears in paintings as a courageous young man raising his sword against a dragon.

Archangel Raphael

He is merciful and the guardian of Eden's Tree of Life.

Archangel Gabriel

He told Mary that she was to be the mother of Jesus. In paintings of the Annunciation, he carries a lily.

Archangel Uriel

He administers the law, and on Judgment Day will revive the good and cast the wicked into Hell.

Free Creation (Designing Angels)

Knowing the Angels You Want to Create

Some of the keywords for angels are holy, charitable, innocent, pure, guiltless, and fair, which all represent the good. You can get ideas from these keywords to create new types of angels.

Study 1: Where do you place wings? (joint location)

The basic form of an angel is "a human body with wings on his back," but in free creation, you can consider any location from head to toe to place the wings. (See p. 24.)

Study 2: How many pairs of wings do you place? (number of wings)

Wings define the angel's class and physical strength. Think about the location and number of wings you need to place. It may be interesting to attach several pairs of wings in several places.

Study 3: Types and shapes of wings

It is said that the painters of the Renaissance period drew angels' wings as imitations of swans. You can think freely about the types and shapes of wings. It is even possible to imitate the wings of other birds.

Creating angels in different forms can depict various meanings in angel stories. (See p. 149-151.)

Form Table		Human being	Doll	Mammal	Fowl	Reptile	Amphibian	Fish	Insect	Plant	Machine	Building	Tool
Fixed form	Horn												
Non-fixed form	Ear												
Collective form	Eye												
Mechanical form	Fang	O	O	O	O	O	O	O	O	O	O	O	O
Cracked form	Tongue												
Increase/decrease	Wings												
Length span	Tail												
Growth	Claw												
Combination	Skin												
	Scissors												

Basic form:

human being + wings
You can create an angel with its wings attached to a creature other than a human being and then personify it.

Affectionate Angels
Desire to heal and to save

Angels have positive images of being holy, charitable, innocent, pure, guiltless, and fair. This character focuses on the image of charity. What type of emotion or conduct does "being charitable" mean to a human being?

○ beautiful, emaciated young man + swan's wings

☆ wears the royal family crown and attire and holds a cane of a skull

❏ He is the angel family's prince and lives in a castle. He has the power to heal the wounds and illnesses of the people, but becomes weak in doing so. Yet he continues to take care of them even if he gradually becomes thinner. Although he is destined to succeed the royal family, he does not think of this and continues to dedicate himself solely to his service.

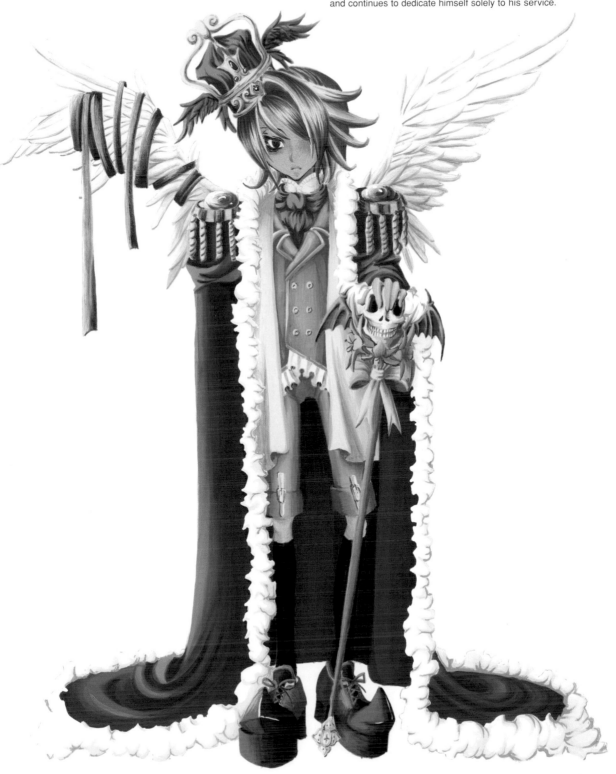

Dream Angel
Desire to be like this angel

The dream angel depicts every man's aspiration to soar freely to the sky and exist closely with God. The image illustrates one's desire to be like her.

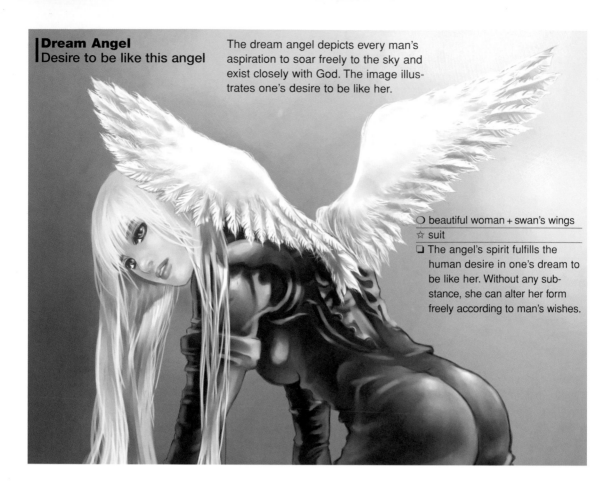

○ beautiful woman + swan's wings

☆ suit

❏ The angel's spirit fulfills the human desire in one's dream to be like her. Without any substance, she can alter her form freely according to man's wishes.

Passionate Angel 1
Desire to protect and be protected

Human passion and hatred are controlled by the power of affection and abhorrence, based on the direction of Cupid's arrow. Their distorted forms are illustrated by the use of an angel motif.

○ young girl + broken wings

☆ tattoo seal on the chained arms

❏ Although she represents the highest-ranking angel in the angel family, the Passionate Angel 1 was born from a human mother and an angel father. She is gentle and pure, yet is treated cruelly by her father since her mother died at the time of her birth.

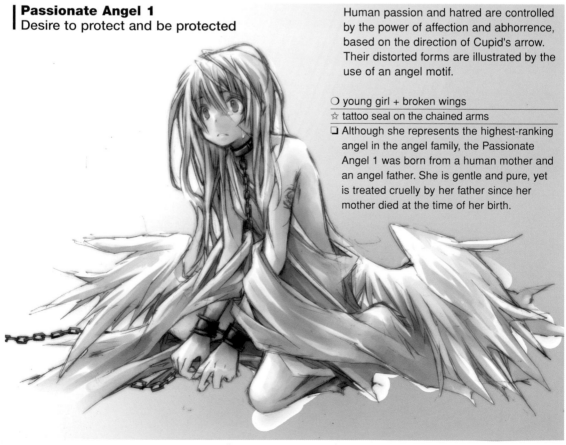

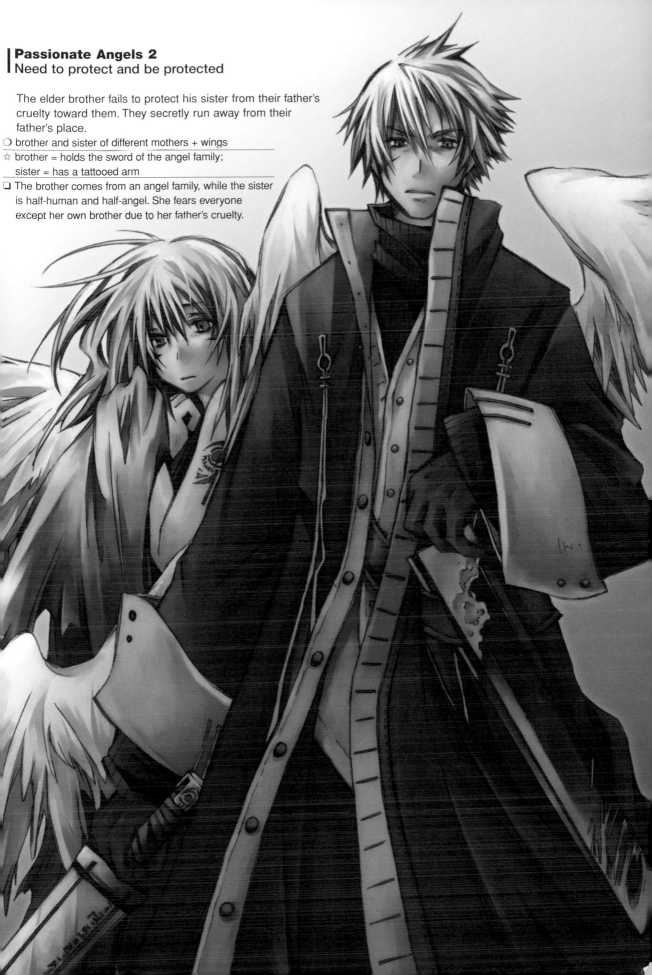

Passionate Angels 2
Need to protect and be protected

The elder brother fails to protect his sister from their father's cruelty toward them. They secretly run away from their father's place.

○ brother and sister of different mothers + wings

☆ brother = holds the sword of the angel family; sister = has a tattooed arm

❏ The brother comes from an angel family, while the sister is half-human and half-angel. She fears everyone except her own brother due to her father's cruelty.

Angel-like Beast
Desire to trick

This character is Cupid, who likes tricks. He shoots arrows from the top of a chimney; thus, he is designed with a hawk's image that supports hawk's wings.

○ young man + hawk's wings
☆ holds metal arrows
❏ One day, he flies into the city of human beings, and shoots a human passerby capriciously with his metal arrow. The human being who was shot becomes an evil half-human character.

Small Angel-like Devil Creature
Desire to become an angel

A human being cannot
become an angel,
even if he uses the most
advanced technology.
Yet, this desire shows the
dream of getting closer
to divinity.

○ young man + angel's halo + mechanical wings
 + mechanical tail

☆ attire including a three-leaf clover emblem
 as the town's symbol

❏ He lives in the city of the future. He is an
 android that desires to be an angel, but fails
 and becomes a little devil.

This devil is a physical embodiment of the negative emotion that surges from the inner souls of human beings. He always feels depressed due to his negative mentality and low spirits. Unlike the other devils, he settles and lives in the human mind, which is his original nest, and draws out negative human emotion. He then swallows it and grows.

Fallen Angels and Devils

Fallen Angels and Devils

Angels are intelligent and beautiful beings with six wings and three faces until they fall from the sky. Then they become incarnations of the power of darkness against light and evil against good. Sample forms are: 1. An evil half-human character with bat's wings, a tail, and hoofs. 2. An evil half-human character combined with a snake, a dragon, and a goat.

The devil was originally called "Lucifer." He was one of the Seraphim angels, placed in the highest spot in Heaven. Although he was the most intelligent, beautiful, and powerful being after God, he became haughty and antagonized God. He was sent to hell and finally became Satan. After the Middle Ages, the figure of Satan was drawn as an evil half-human character like the idol of Baphomet, which is a combination of a human being and a goat's head and lower body. This representation became the embodiment of evil. Satan takes advantage of human weakness and desires, tempts humans to commit the Seven Deadly Sins, and bargains with them.

Seven Deadly Sins: Sins that must never to be committed; a devil exists in every sin.

1.Pride-Lucifer
He was intelligent and beautiful and most loved by God. He was transformed into a devil because he was haughty.

2. Avarice-Mammon
He represents hunger for the world's wealth and authority.

3.Lust-Asmodeus
He has the head of a bull, human, and sheep; ostrich's legs; and a snake's tail. He rides on a dragon.

4.Wrath-Satan
He is a sovereign of Hell who leads the fallen angels.

5.Gluttony-Beelzebub
He ranks second in Hell after Lucifer.

6.Envy-Leviathan
He lives in the sea and is a huge snake or dragon.

7.Sloth-Belphegor
He was sent from Hell to search for the meaning of marriage.

Free Creation (Designing Fallen Angels and Devils)
Knowing the Fallen Angel and Devil You Want to Create

The keywords for devils have evil meanings and are mainly represented by the seven deadly sins. These words help create new types of devils.

Study: Degree of Deformation
The idol of Baphomet is the embodiment of a figure that has completely lost human reasoning and depicts the beast's desires. The difference between fallen angels and devils is the degree of changing the basic shape of an angel before its fall.

Basic form: Human being x bat, tail, goat's parts and one body part

Form Table

Fixed form
Non-fixed form
Collective form
Mechanical form
Cracked form
(Increase/decrease)
Length span
(Growth)
(Combination)

	Human being	Doll	Mammal
Horn	○		
Ear			
Eye	○		
Fang	○		
Tongue			
Wings	○		
Tail	○		
Claw			
Skin			
Scissors			

	Human being	Doll	Mammal	Fowl	Reptile	Amphibian	Fish	Insect	Plant	Machine	Building	Tool	Other elements
Human being			○			○							
Doll			○			○							
Mammal	○	○				○							○
Fowl													○
Reptile	○	○	○										○
Amphibian													
Fish													○
Insect													
Plant													
Machine													
Building													
Tool													
Other elements	○	○	○		○								

Beautiful but Frightening Devil
Desire to attack

This creation brings about the hallucination of a devil that appears as a beautiful lady and attacks in a dark street at night.

○ beautiful lady ı bat's wings + bull's horn + snake's eyes (ferocious creature with deformed hands and fingers)

☆ suggests darkness with a black, torn cloth

❏ This creature is a beautiful devil that appears in the city at night. She was originally a beautiful human woman, but was possessed with sexual desires, and thus was transformed into a devil. She appears as one of the most beautiful women, but once you approach her and are enchanted by her beauty, she transforms herself into a devil and attacks you. She is vulnerable to the Crucifix, light, and other women who are more beautiful than her.

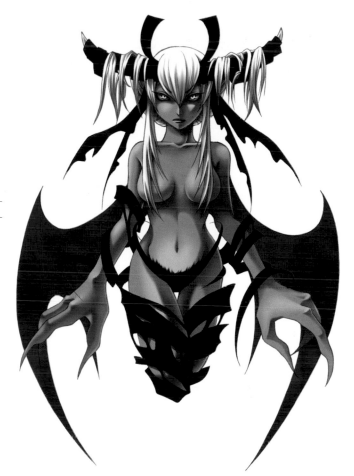

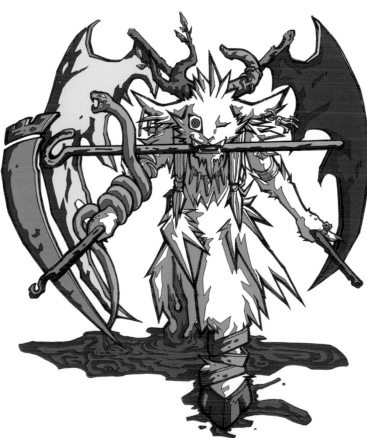

Devil in the Slums
Desire to breathe life

There are people who are tired of living and hang around the slums. This creature is a devil that hangs out there.

○ goat's body as the base structure; goat x modern person + bat's wings + branch's thorns + snake's eyes

☆ pieced earrings, bracelet, rings, and other accessories; holds an ax in its mouth and a club in its hands

❏ When humans are tired of living, this creature appears and tries to drag them toward corruption. It is vulnerable to natural light; hence, it can move only at night. When it is exposed to the sun, its body melts and evaporates.

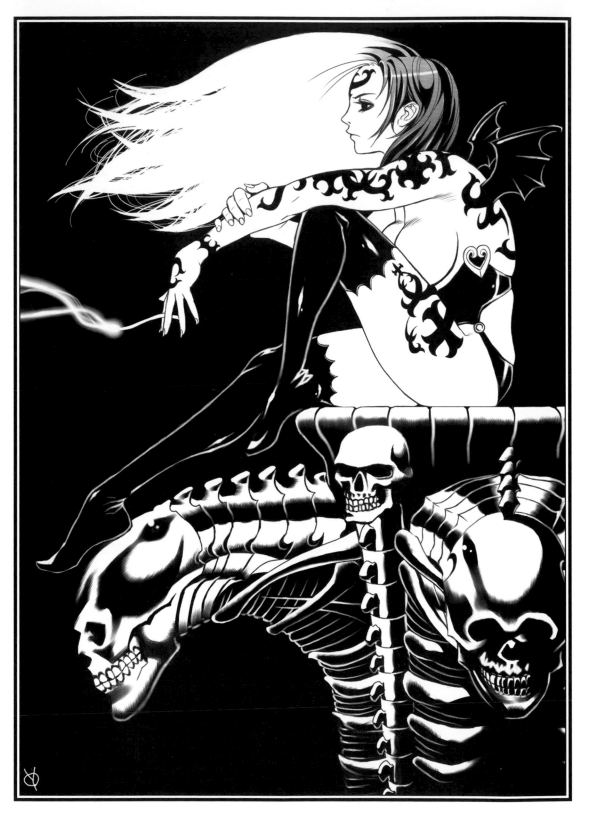

Bored, Dark Angel
Desire to be stimulated

The image is created from an immortal dark angel who lives in the devil's world and who is bored, having too much time to herself.

○ beautiful lady + bat's wings

☆ black attire, tattoo

❏ This dark angel lives in the devil's world and spends her time on top of a tower where she surveys the devil world. She can live for hundreds of years but is lazy. She is vulnerable to light.

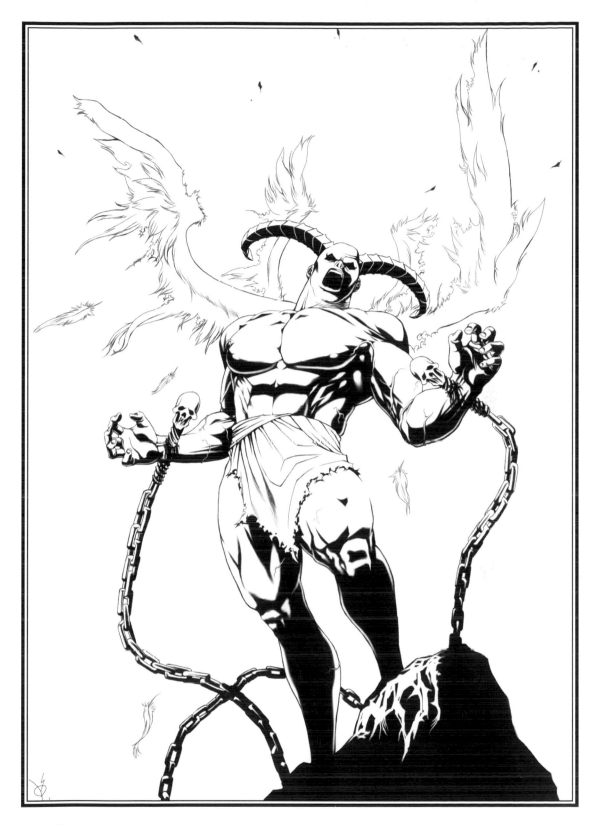

Devil-transformed Fallen Angel
Desire to be superior to God

This image is created from the fallen angel Lucifer, who fell into Hell and was transformed into the ultimate form of devil.

○ muscular man + swan's wings + goat's horns

☆ waistband

❑ In Hell, Lucifer pierced his arms with chains, his wings fell off, and horns grew on his head. He lost the light, but gained magical power. He desires to be superior to God.

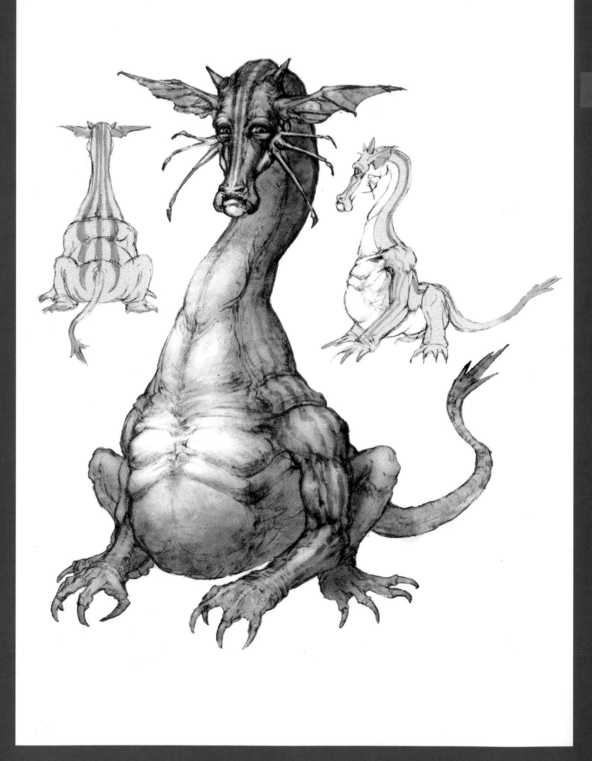

This dragon combines a lizard's body with a bat's wings that were used for ears. It is much more intelligent than man and attacks using magical powers.

Dragons

Dragons

Western-style dragons are intelligent evil beasts with lizard-like bodies, bat-like wings, and sharp claws. Eastern-style dragons are holy beasts that have deer's horns, bull's ears, horse's or camel's heads, ogre's eyes, tiger's palms, hawk's claws, carp's scales, whiskers, and large snake bodies.

Western-style dragons blow fire or cold breath, and some also use magic. Eastern-style dragons are holy beasts. They control the seawaters, rivers, rain, and wind. They embody the rage of nature, such as volcanic eruptions, storms, and floods.

Dragon Groups — from evil symbols to figures of nature's rage

Wyvern-heraldry
This dragon has no forelegs, but has bat-like wings, sharp claws, and fangs and attacks other creatures from the air.

Wyrm-folklore
This dragon has no hands or legs, and its figure resembles a snake with wings. It also attacks other creatures from the air.

Stoorworm
This dragon is a monster-like caterpillar that blows cold breath.

Basilisk-legend
This dragon is a combination of a lizard and a chicken. Deadly poisonous, it lives in the desert and petrifies other creatures by staring at them.

Fefnir-Scandinavian myth
This dragon is covered with hard scales, has a tail and sharp fangs, and blows poisonous breath.

Tiamat-Babylonian myth
This primordial dragon has seven necks. In paintings, it has a female upper body and a snake-like lower body.

Hydra-Greek myth
This dragon is a water-snake monster that has nine heads.

Ladon-Greek myth
This dragon is an immortal monster from Greek mythology. It has one hundred heads and a long neck that can reach the heavens when it is stretched.

Chimaira-Greek myth
This multiformed beast has a head of a lion and a body of a he-goat dragon. It lives in the volcanoes.

Free Creation (Designing Dragons)

Form Table
Fixed form
Non-fixed form
Collective form
Mechanical form
Cracked form
Increase/decrease
Length span
Growth
Combination

Knowing the Dragon You Want to Create

You can create a western-style dragon based on the basic forms described above.

Using a reptile or amphibian body as the base structure

In creating dragons, you can use a reptile or an amphibian body, and combine other animal body parts or physical components.

	Human being	Doll	Mammal	Fowl	Reptile	Amphibian	Fish	Insect	Plant	Machine	Building	Tool
Horn					O	O						
Ear					O	O						
Eye					O	O						
Fang					O	O						
Tongue					O	O						
Wings					O	O						
Tail					O	O						
Claw					O	O						
Skin					O	O						
Scissors					O	O						

	Human being	Doll	Mammal	Fowl	Reptile	Amphibian	Fish	Insect	Plant	Machine	Building	Tool	Other elements
Human being					O	O							
Doll					O	O							
Mammal					O	O							
Fowl					O	O							
Reptile	O	O	O	O	O	O	O	O	O	O	O	O	O
Amphibian	O	O	O	O	O	O	O	O	O	O	O	O	O
Fish					O	O							
Insect					O	O							
Plant					O	O							
Machine					O	O							
Building					O	O							
Tool					O	O							
Other elements					O	O							

Western-style Dragons

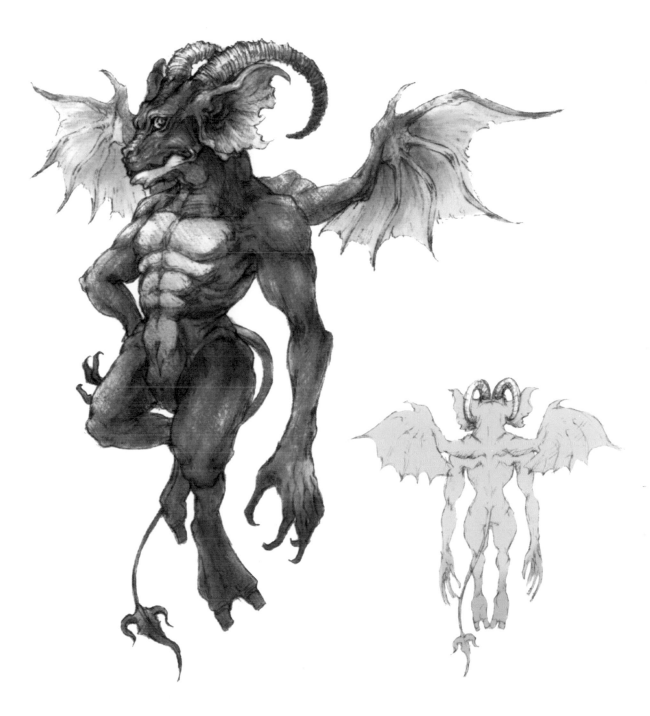

Baphomet Dragon (masculine form)

This image shows Satan, who lives in Pandemonium. His useful claws have the ability to control the wind at their own will. It is a combination of the Baphomet dragon and an evil beast dragon.

○ alligator x dog x male human being + goat's horns + bat's wings + elephant's ears + devil's tail

☆ naked

❏ This masculine Baphomet dragon possesses wind attributes. He flies fast and attacks other creatures with his long fingers and sharp claws. He is Satan's useful tool in Pandemonium and is intelligent, cunning, and never misses his prey. He fumes by flapping his wings.

Baphomet Dragon (feminine form)

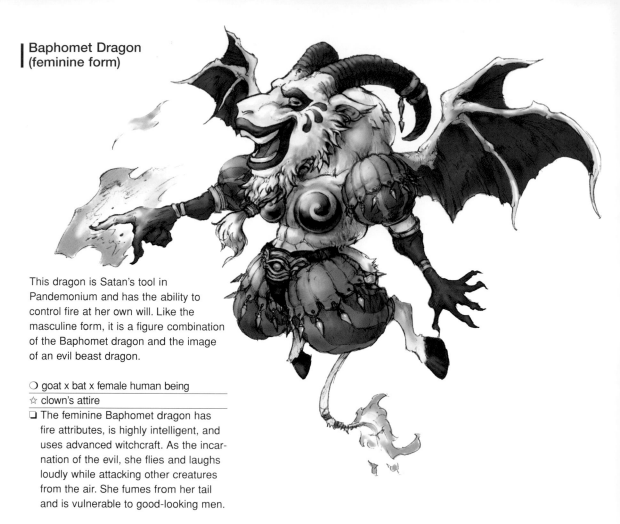

This dragon is Satan's tool in Pandemonium and has the ability to control fire at her own will. Like the masculine form, it is a figure combination of the Baphomet dragon and the image of an evil beast dragon.

○ goat x bat x female human being

☆ clown's attire

❏ The feminine Baphomet dragon has fire attributes, is highly intelligent, and uses advanced witchcraft. As the incarnation of the evil, she flies and laughs loudly while attacking other creatures from the air. She fumes from her tail and is vulnerable to good-looking men.

Guardian Dragon of Secret Treasures

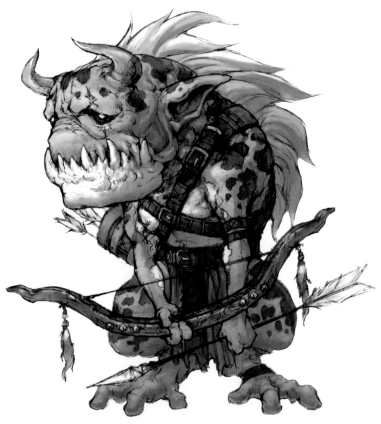

This dragon is loyal to Satan and lives in Pandemonium for hundreds of years as a guardian of secret treasures. The character can be created as a faithful guard, watchdog, or bulldog.

○ frog's skin x bulldog's face x male human being + horns + fangs + mane

☆ hunter's attire, bow and arrow

❏ As an expert archer, this dragon never misses the target. He is the guardian of the secret treasures in Pandemonium. He cannot fly because he does not have wings, but he is a fast runner and a good swimmer. He can live both in the ground and under water and blows cold breath.

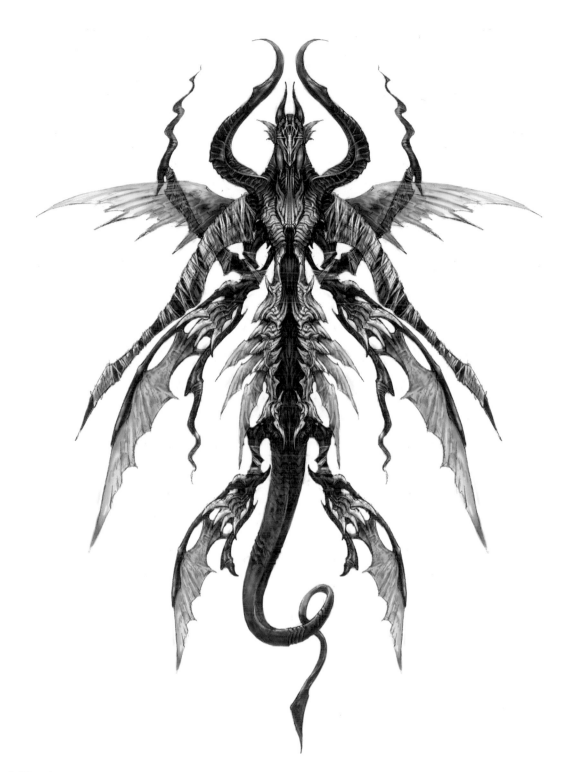

❚ Mandragon

As the leader of the dragons, the mandragon organizes the western-style and eastern-style dragons together and supervises all the animals and plants on the earth. It is the most omnipotent and strongest dragon of all and is a combination of an insect (stag beetle) and a marine creature (sea horse).

○ stag beetle x lizard x fish x sea horse + six pairs (twelve) of wings

☆ modeled after a mummy

❏ The mandragon has a gigantic body and is the strongest dragon of all. It is the leader of the dragons and all animals and plants. It generates any natural catastrophe at its own will, and it controls the Universe.

Western- and Eastern-style Dragons

The previous sections introduced sample free creations of western-style and eastern-style dragons. We can further compare and examine the two types of dragons.

As an example, the western-style dragon can be a basic form of the Basilisk dragon, a lizard-shaped dragon combined with a chicken. (See p. 54.) On the other hand, the eastern-style dragon can be created from the original forms of a deer's horns, bull's ears, horse's head, ogre's eyes, tiger's palms, hawk's claws, carp's scales, whiskers, large snakes' bodies, with only one scale in an opposite pattern under its chin.

The western-style dragon is drawn like a type of fierce animal with wings, but the eastern-style dragon is drawn like a holy beast that has a long snake-like body. (See the western-style and eastern-style dragon differences on p. 54.)

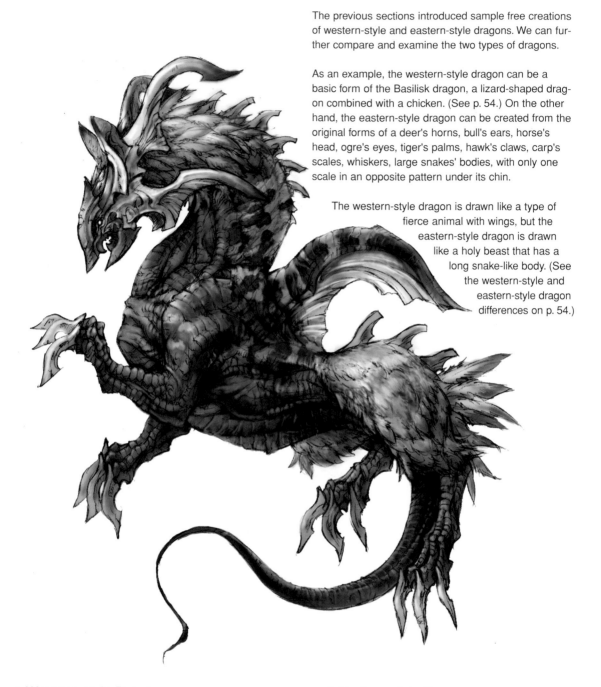

▌ Western-style Dragon

◯ lizard x deer x chicken + eagle's claws (created from the Basilisk dragon's basic form)

☆ naked

❏ This dragon is deadly poisonous and lives in the desert. It attacks other creatures from the air with its sharp claws and petrifies them by staring at them.

▌ Eastern-style Dragon

◯ smoke x basic form of the eastern-style dragon

☆ naked

❏ A hermit enjoys the slow life in the hermits' world and creates a dragon out of the smoke from his pipe.

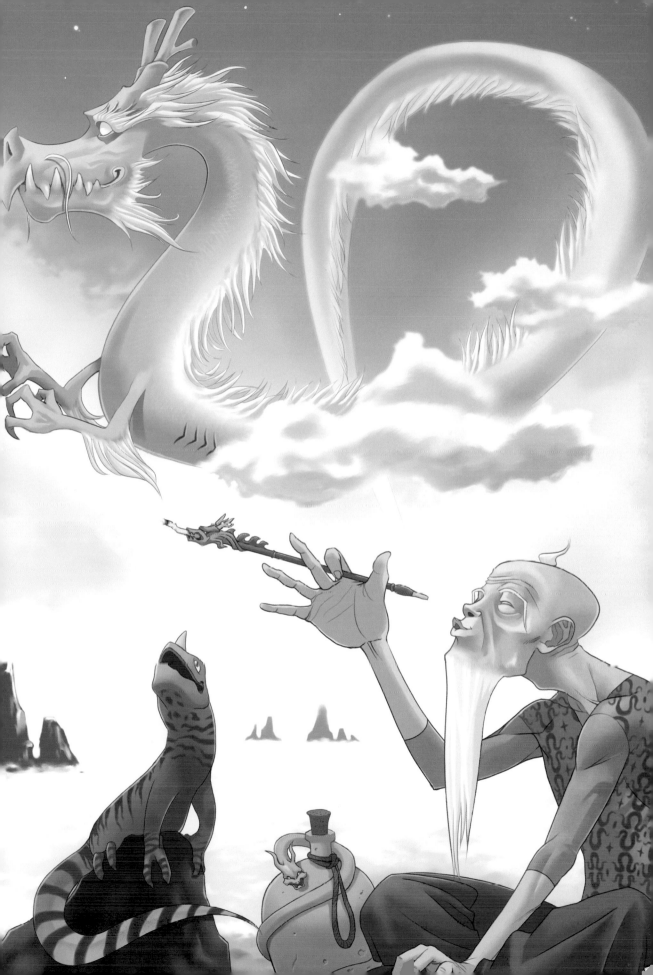

Tall Tales from Greek Mythology

Many imaginary characters appear in Greek mythology, and they are said to be the original forms of half-human creatures and multiformed beasts. Some of the most well-known monsters are listed here. In creating characters one can imagine being in the dreamy world of Greek mythology.

Hercules' Twelve Labors

Zeus, the supreme and omnipotent Olympian god, had a child with Alcmene, the wife of the Theban general Amphitryon. The child's name was Hercules. Hercules soon grew up to be strong and honorable. Zeus' wife, Hera, was very jealous and vindictive. Hercules left Thebes, and at the Oracle of Delphi was told: "You must carry out twelve labors for the king of Mycenae, Eurystheus, within twelve years." Hercules accomplished them all brilliantly.

1. Nemean Lion
This lion was so fierce and immortal that it could not be hurt with any weapon, but Hercules strangled it with his bare hands.

2. Lernaean Hydra
Hydra had nine heads, but only one needed to live. Hercules cut off its many heads and the one needed for life.

3. Hind from Ceryneia
The hunter-goddess Artemis protected this female deer with gold horns. To avoid her wrath, Hercules gently caught it alive.

4. Erymanthian Savage Boar
This savage boar lived in the Erymanthus mountain and Hercules chased it and brought it to King Eurystheus.

5. Stall of Augeas
King Augeas had not cleaned his stables for 30 years. Hercules changed the flow of two rivers, flushing out the stables in a day.

6. Stymphalian Birds
These deadly birds lived by Lake Stymphalus. Hercules killed them with poison arrows he had made from the Hydra's blood.

7. Cretin Bull
Hercules caught this violent bull alive. It had been sent out by the sea god Poseidon to threaten King Minos of Crete.

8. Thracian Horses
Hercules caught the four horses of King Diomedes of Thrace, which fed on human flesh, then killed the King.

9. Battle of the Amazons
Hercules was ordered to get the belt that had been given to the queen of the Amazons by Ares. Hera spread the rumor that Hercules was an enemy then a battle ensued.

10. Geryon's Oxen
Hercules caught the three-headed Geryon's oxen and brought them back to Mycenae.

11. Golden Apples of the Hesperides
Hercules asked the Titan Atlas to fetch the apples of Hesperides. Hercules carried the world on his shoulders while Atlas got the apples.

12. Cerberus
With his bare hands, Hercules journeyed to the underworld, caught the three-headed dog Cerberus, and brought it back to Mycenae.

Centaur
Therianthropic tribe symbolic of Sagittarius

This tribe originated from a race that was half-man and half-animal (therianthropic). Hercules fought against them when he went out to catch the savage boar in the Erymanthus mountain. The tribesmen lived in hills and fields and ran around with bows and arrows. They were barbaric, violent, and lecherous. Hercules defeated them with arrows that were varnished with Hydra's poison. The heroic leader Chiron was the most intelligent tribesman. When he died, Zeus regretted it and sent him up to the night sky, where he became the symbol of Sagittarius.

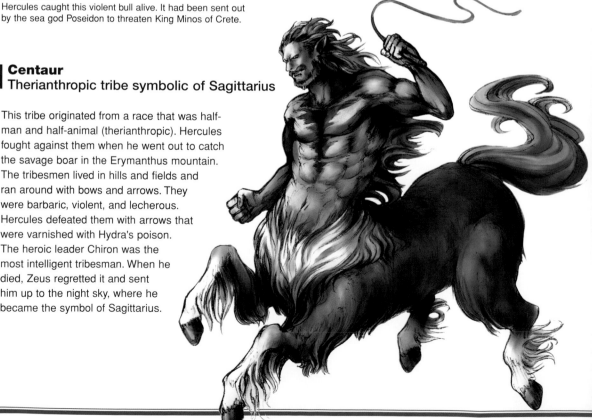

▌Lernaean Hydra

Brave Hercules was ordered by Eurystheus to get rid of Hydra, a huge sea snake-shaped dragon that lived in the Lerna swamps. Hydra was fearful and had nine heads. When one of the heads was cut off, the monster regenerated two new ones. Hercules cut off all but the vital head then ordered his nephew Lolaus to burn the cuts with a torch to prevent the heads from regenerating. Eventually, this method got rid of Hydra. Hydra is the symbol of the constellation Hydra.

Minotaur
Tragic prince who was born as a monster despite his noble blood

Tetheus, the hero of Athenae, invaded Labyrinthus, disguised himself as one of the sacrifices and defeated the Minotaur. Later, he escaped from Labyrinthus by using the thread that King Minos' daughter Ariadne, had given him.

King Minos' bull, Taurus, had a human body and a bull's head. Minos broke his promise with Poseidon, the sea god, and failed to sacrifice the bull. As a punishment, Queen Pasiphaë was made to fall in love with the bull and gave birth to the Minotaur. The Minotaur became mad and violent, and King Minos ordered the skillful craftsman Daedalus to build a labyrinth to confine the monster.

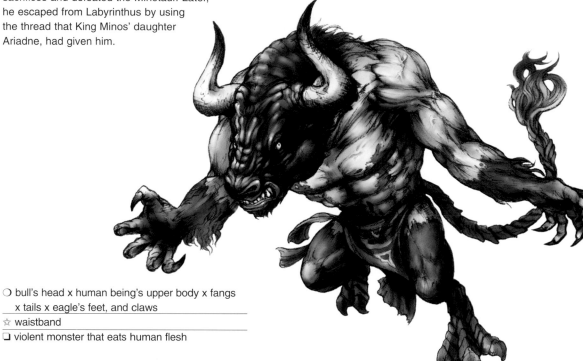

❍ bull's head x human being's upper body x fangs
 x tails x eagle's feet, and claws
☆ waistband
❏ violent monster that eats human flesh

Cerberos
Fierce dog that guards the bronze gate of Tartarus

Tartarus was the underworld "abyss," where dead people gathered. King Hades ruled this underworld, and Cerberos was a watchdog that was stationed at the bronze gate there. Cerberos was a monster that had three heads and a snake-like tail. It welcomed the dead by wagging its tail, but it attacked live creatures mercilessly and those who tried to escape from the underworld. Hercules had a battle with Hades, and at the end of the deadly combat, he captured Cerberos with his bare hands and brought it out from the ground.

❍ three dogs' heads x rock x flame; horns x fangs
☆ sculpture
❏ violent monster petrifies other creatures by staring at them

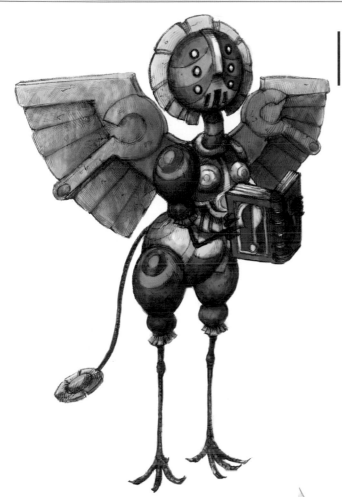

Sphinx
"I have four legs in the morning, two during the day, and three at night. What am I?"

In Greek mythology, the Sphinx was described as a monster with a female upper body, a lion's lower body, and an eagle's wings. She was highly intelligent and lived in Mount Phikion. She often stopped passersby to ask, "I have four legs in the morning, two during the day, and three at night. What am I?" If the passersby could not answer her, they would be eaten. However, Prince Oedipus of Corinth found the answer to this riddle. "It's a human being. When he is born, he cannot stand up yet, so he crawls with 4 legs. When he grows up, he learns to stand and walks with two legs. When he is old, his legs become weak, so he needs a stick to walk." When Sphinx knew that she lost the game, she threw herself from the city walls and died.

○ female body frame x doll x eagle's legs; mane + wings + tail + rock (design of a deformed body)
☆ decoration of question marks on the wings; holds a riddle book
❏ As a monster who loves riddles, she asks difficult questions when she encounters people. If the people cannot answer her questions, she eats and kills them

Medusa
Tragic, beautiful lady who was transformed into an ugly monster by female jealousy

The monster Medusa had a frightening appearance. She had hair made of snakes, boar-like fangs, and golden wings and she could petrify others merely by looking at them. Originally she was known for her beauty, especially for her extraordinary hair. Poseidon fell in love with her, but his jealous wives transformed her beautiful hair into snakes.

○ female upper body x snake's lower body; snake's hair x eyes x tongue x fangs x claws x golden wings
☆ tattoo
❏ violent monster that petrifies other creatures simply by looking at them

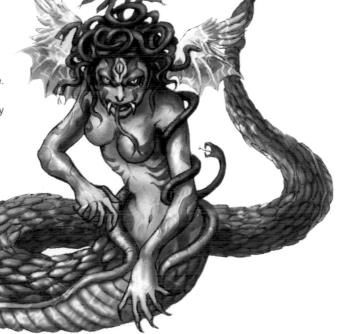

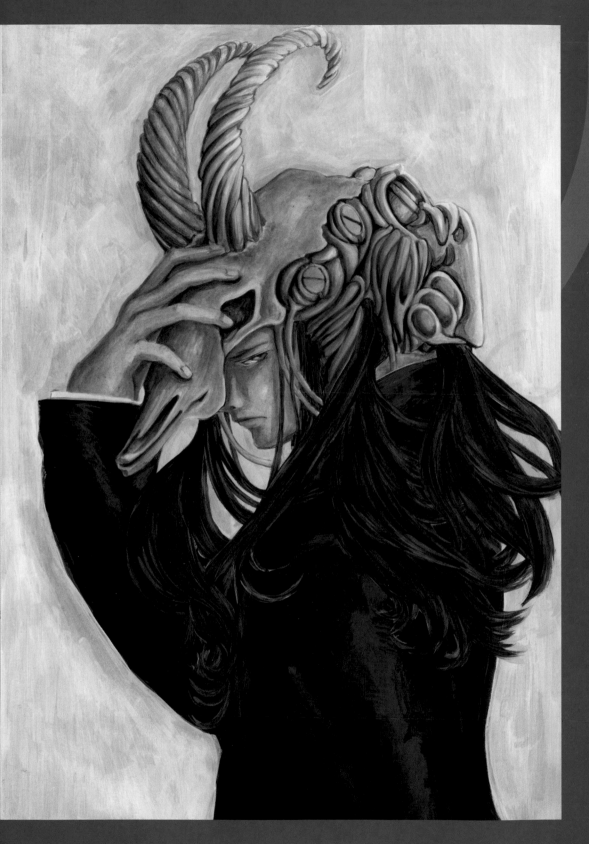

This illustration shows a figure of a rational human combined with beastly instinct.

Nonhuman Creatures and Phantom Beasts

Nonhuman Creatures

Nonhuman creatures are half-human characters that have human bodies combined with the body parts of other creatures. They can also resemble beasts, having human bodies combined with the bodies of other creatures.

They are complex living beings. Animals and insects have been personified as imaginary creatures in mythology and folklore because of their remarkable physical structures. They resemble human beings, but are not human. Those creatures that resemble human beings are images of rational beings, but those that resemble beasts project a wild or savage image.

What types of existence do nonhuman creatures have?

Existence for worship
These creatures are respected because they possess superior abilities over human beings.

Existence for love
These creatures are loved as pets and are regarded as family members or lovers.

Existence for oppression
These creatures are oppressed because they resemble human beings even if they are not human.

Existence for fear
Creatures such as phantoms, monsters, and goblins are feared because they threaten human lives.

Free Creation (Designing Nonhuman Creatures)

Form Table
Fixed form
Non-fixed form
Collective form
Mechanical form
Cracked form
(Increase/decrease)
(Length span)
(Growth)
(Combination)

Knowing the Nonhuman Creature You Want to Create. Some keywords for nonhuman creatures are first impressions, such as cute, ugly, and violent and expressions that signify human relationships, such as friends, partners, livestock, and pets.

Study: Using a human or another creature's body as base structure

To create a nonhuman body freely, you must first decide whether to use a human or another creature's body as its base structure. You can then express its difference from the human form.

	Human being	Doll	Mammal	Fowl	Reptile	Amphibian	Fish	Insect	Plant	Machine	Building	Tool
Horn	O											
Ear	O											
Eye	O											
Fang	O											
Tongue	O											
Wings	O											
Tail	O											
Claw	O											
Skin	O											
Scissors	O											

	Human being	Doll	Mammal	Fowl	Reptile	Amphibian	Fish	Insect	Plant	Machine	Building	Tool	Other elements
Human being	O	O	O	O	O	O	O	O	O				
Doll	O												
Mammal	O												
Fowl	O												
Reptile	O												
Amphibian	O												
Fish	O												
Insect	O												
Plant	O												
Machine													
Building													
Tool													
Other elements													

Creating from Human Forms

Friendly, human-like characters

Fox boy who possesses psychic powers

Foxes are said to possess psychic powers, and there are many tales and superstitions about them. Some stories talk about a deceiving fox that is disguised as a human being. The character illustrated here is a creation from such a desire image.

○ boy + fox's ears and tail

☆ fox mask, mountain priest attire, Japanese geta clogs

❏ This fox is a boy with psychic powers. He lives long by gaining his energy from the souls of the dead. He is scared of guns, and likes deep-fried tofu.

Chicken boy who delivers newspapers

This character is created from the desire image of a chicken that wakes up humans early in the morning and delivers newspapers.

○ boy x chicken + horns

☆ plain clothes, bag, newspapers

❏ He is hard-working and wants to save enough money to buy his own chicken shed house.

Cat girl who is personified from a domesticated cat

This character is imagined as a cute pet cat that could be a human being.

○ girl x cat's ears and tail

☆ collar, plain clothes

❏ She is amicable, affectionate, and happy when petted on her head. She sleeps during the day because she is nocturnal. She likes high places, so she always takes a nap on the roof.

Tutor with a combined body of a schoolteacher and a lizard

The desire image for this character is a science teacher who always asks students to study more. One might be able to study harder if he were a private tutor.

○ high school science teacher x lizard's lower body

☆ scarf, glasses

❏ He approaches students who do not have a strong will to study, and tutors them strictly until they finish their work. He loves sweets, and is vulnerable to alcohol and women.

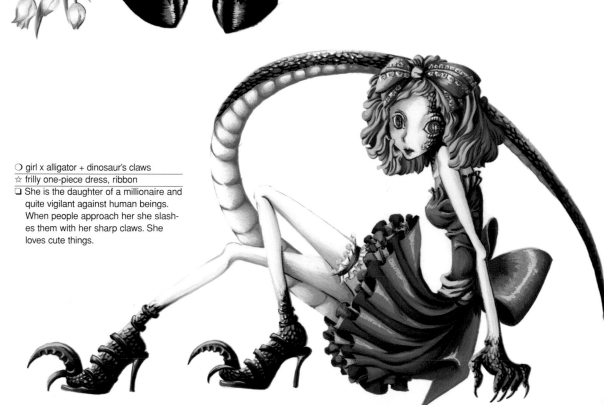

Charming but frightening, innocent, and wild beastly girls

Even charming girls have animals' barbaric instincts, as expressed in the saying, "beautiful roses have thorns." The character illustrated here is the creation of such an image.

○ girl x horse's lower body; girl + horns + tulip's tail
☆ hat, belt, ribbon
❑ She lives in the woods, and talks to people who enter it. People feel secure about her because she is charming; yet, she kicks them with her horse legs once they get close to her. She is barbaric and violent and is vulnerable to fire.

○ girl x alligator + dinosaur's claws
☆ frilly one-piece dress, ribbon
❑ She is the daughter of a millionaire and quite vigilant against human beings. When people approach her she slashes them with her sharp claws. She loves cute things.

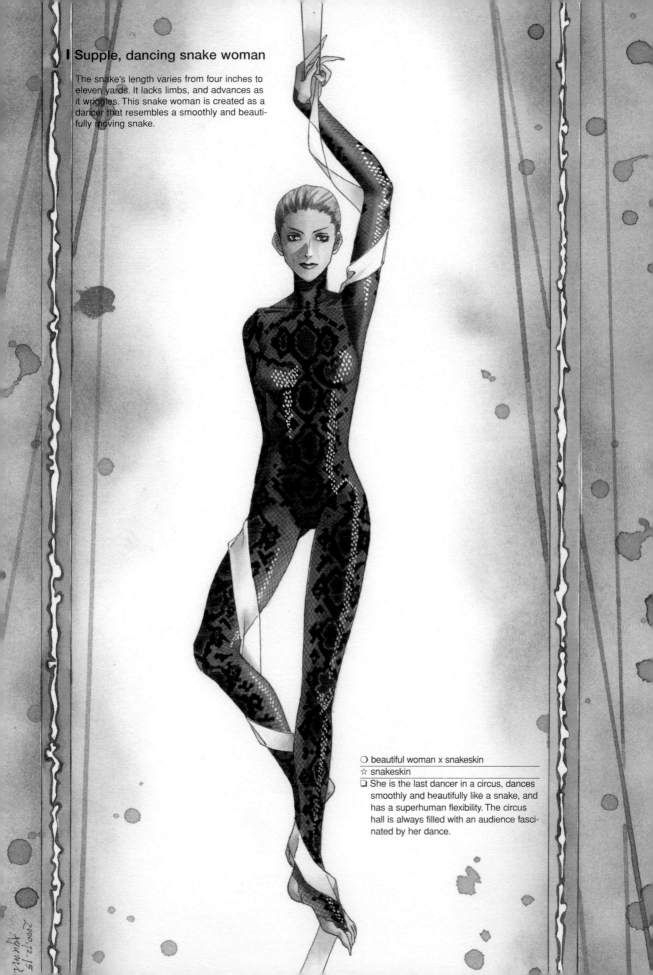

Supple, dancing snake woman

The snake's length varies from four inches to eleven yards. It lacks limbs, and advances as it wriggles. This snake woman is created as a dancer that resembles a smoothly and beautifully moving snake.

○ beautiful woman x snakeskin

☆ snakeskin

❏ She is the last dancer in a circus, dances smoothly and beautifully like a snake, and has a superhuman flexibility. The circus hall is always filled with an audience fascinated by her dance.

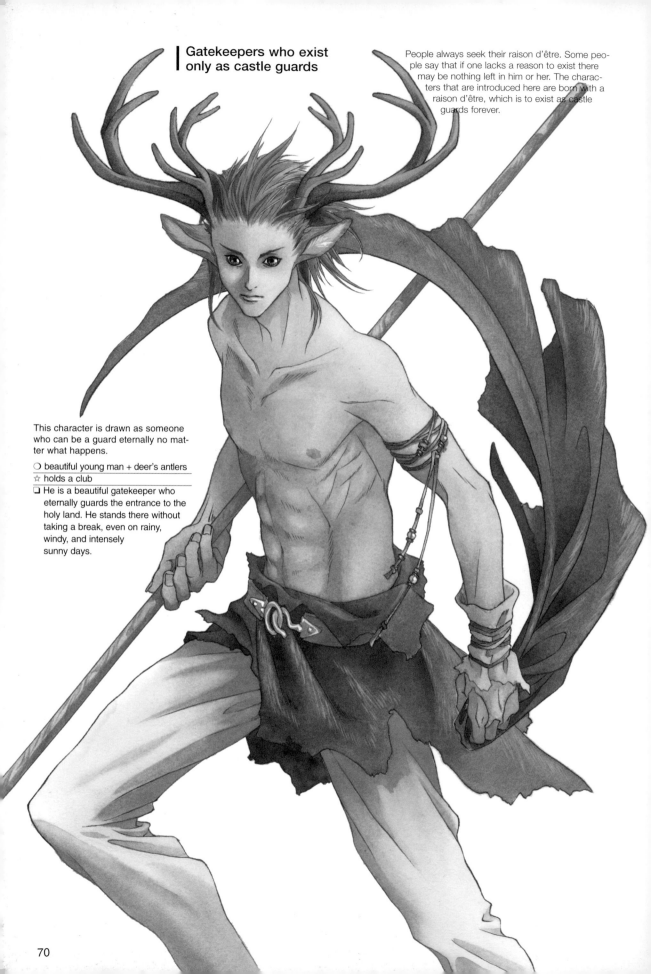

Gatekeepers who exist only as castle guards

People always seek their raison d'être. Some people say that if one lacks a reason to exist there may be nothing left in him or her. The characters that are introduced here are born with a raison d'être, which is to exist as castle guards forever.

This character is drawn as someone who can be a guard eternally no matter what happens.

○ beautiful young man + deer's antlers
☆ holds a club
❏ He is a beautiful gatekeeper who eternally guards the entrance to the holy land. He stands there without taking a break, even on rainy, windy, and intensely sunny days.

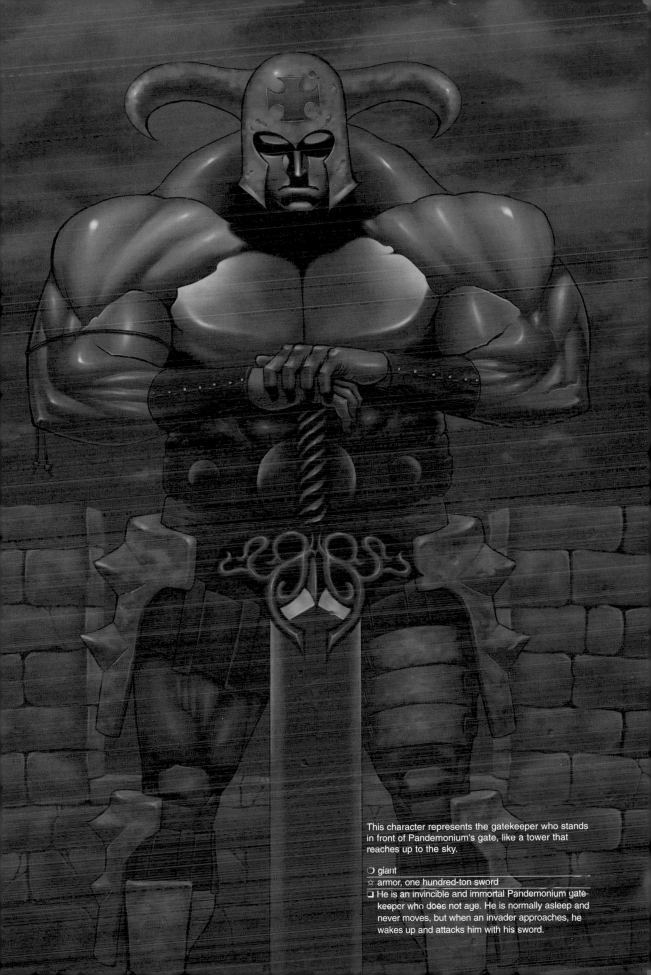

This character represents the gatekeeper who stands in front of Pandemonium's gate, like a tower that reaches up to the sky.

○ giant
☆ armor, one hundred-ton sword
❏ He is an invincible and immortal Pandemonium gatekeeper who does not age. He is normally asleep and never moves, but when an invader approaches, he wakes up and attacks him with his sword.

Creating from Animal Forms

Imagining animals that possess human minds

Boy collector who gathers rare articles from all over the world

A cat is agile, and travels anywhere. This creation projects the desire to become agile, like a cat that can travel around the world and collect many rare articles.

○ cat x boy

☆ gloves, scarf, bag full of rare articles

❏ This character travels around the world to collect rare articles. When he encounters someone, he asks him/her if he/she has any rare objects. He is curious and full of vigor.

Cat swordsman who guards the entire district

This cat appears charming, but is also violent. It is created as a swordsman who has the dual characteristics of using two different faces.

○ cat x samurai

☆ Japanese *haori* (short, formal coat), scarf, pierced earrings, ring, sword

❏ He works in a grocery, but is really a swordsman who guards the entire district. He has a particular speech characteristic, is normally slow, but can be quick during a battle. He likes small dried sardines and is scared of eye drops.

High-class, intelligent, and elegant nobleman

This creation illustrates the desire to spend time in the afternoon with an intelligent, elegant, and noble cat.

○ cat x scholar

☆ high-class attire, herbal tea

❏ He is a high-class nobleman who loves herbal tea. His job is to decode ancient documents and he aspires to collect them. He knows everything about the world; thus, he can answer any question.

Traveling group of secret treasure hunters

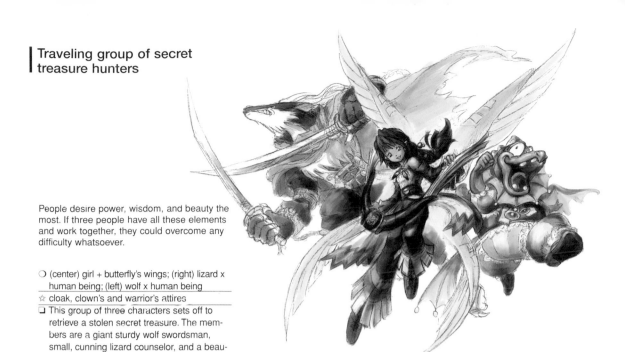

People desire power, wisdom, and beauty the most. If three people have all these elements and work together, they could overcome any difficulty whatsoever.

○ (center) girl + butterfly's wings; (right) lizard x human being; (left) wolf x human being

☆ cloak, clown's and warrior's attires

❏ This group of three characters sets off to retrieve a stolen secret treasure. The members are a giant sturdy wolf swordsman, small, cunning lizard counselor, and a beautiful fairy girl who can practice witchcraft.

Animal warriors

Mice can be found everywhere in the world. They are small, quick, and have a strong reproductive capacity. They are also the biggest animal family. This creation illustrates the image of one of the countless junior mice soldiers.

This creation is based on the strong desire to have a loyal and clever dog that can become a knight to protect the owner eternally.

○ mouse x lizard x human being (personified creative beast)

☆ holds a spear

❏ This character is a junior soldier who belongs to the lower class rank, but outnumbers the other mice. It exists anywhere in the world and attacks sporadically in battles as a group. It is omnivorous, lacks power, but is courageous.

○ personification of a dog as a sturdy man

☆ armor, shield, sword

❏ The character is a pure, clever, and loyal dog knight that fights to protect the princess risking his own life. He has a good sense of smell; hence, he can detect the princess' whereabouts wherever she goes.

Nonhuman Creatures' Desires

Nonhuman creatures do not have human figures, but have human minds. What do humans think about other creatures, and what do they expect from them?

Lonely grasshopper woman who wishes to become human

Sometimes, one wishes to be a different creature, and aspires to live in its world or to obtain its special abilities. How would it feel to become another creature physically while keeping the same human mind?

○ beautiful woman x grasshopper

☆ design of the insect's skin as foundation

❑ The creature is created for the near future, by the genetic manipulation of combining grasshopper and human cells. It longs for some company and aspires to obtain a human body at the price of abandoning its superior ability over humans, which is to fly up to the sky.

Pitiful, therianthropic girl who wishes to gain freedom

There are moments when one wishes to gain freedom. What does "freedom" mean to living creatures? To human beings, freedom means to be mentally and physically unrestrained. But if this is true freedom is there anyone who can actually be free? On the contrary, human beings are born unconsciously restrained by many factors.

○ girl + ears + creative tail design

☆ bound in chains, holds a lamp

❑ This character is a therianthropic girl whom someone bought from the streets. She works in the master's mansion's basement as a lamp-keeper but wishes to obtain freedom and go out to see the outside world.

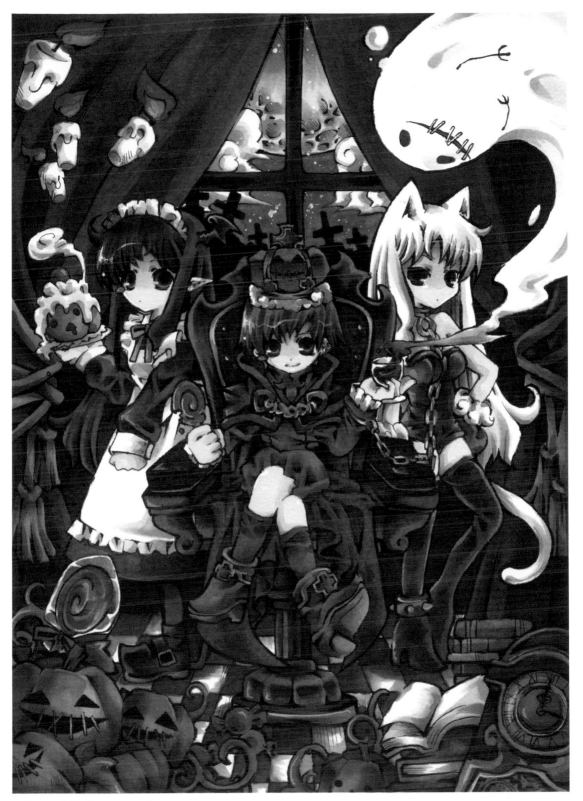

King of Halloween who wishes to rule and be loved

○ (left) room girl attendant + horn-transformed hair; (center) human king; (right) girl pet x white cat

☆ room attendant's attire; king's cloak and crown; black attire and collar for the pet

❏ The king has absolute power. The room attendant trains ghosts and offers them to the king. The pet is a white cat, but wears a black costume because the king likes black cats.

Phantom Beasts

Phantom beasts are rumored to be visible, but their forms are unknown. They can also be imaginary beasts that have varied forms.

Worldwide, there are many stories about mysterious creatures. These include the Japanese *kappa* (water elf), the Loch Ness monster, the Japanese *tsuchinoko* (imaginary snake-like creature), and *hibagon* (imaginary monkey-like creature). They are called monsters, messengers of God, or simply unidentified beasts. Unique multiformed beasts can illustrate the difference between a real and unreal story. If a tale is based on the real world, you can express both reality and fantasy by plotting an encounter with phantom beasts.

Free Creation (Designing Phantom Beasts)
Elements below can be combined freely.

	Human being	Doll	Mammal	Fowl	Reptile	Amphibian	Fish	Insect	Plant	Machine	Building	Tool
Horn	○	○	○	○	○	○	○	○	○	○	○	○
Ear	○	○	○	○	○	○	○	○	○	○	○	○
Eye	○	○	○	○	○	○	○	○	○	○	○	○
Fang	○	○	○	○	○	○	○	○	○	○	○	○
Tongue	○	○	○	○	○	○	○	○	○	○	○	○
Wings	○	○	○	○	○	○	○	○	○	○	○	○
Tail	○	○	○	○	○	○	○	○	○	○	○	○
Claw	○	○	○	○	○	○	○	○	○	○	○	○
Skin	○	○	○	○	○	○	○	○	○	○	○	○
Scissors	○	○	○	○	○	○	○	○	○	○	○	○

	Human being	Doll	Mammal	Fowl	Reptile	Amphibian	Fish	Insect	Plant	Machine	Building	Tool	Other elements
Human being	○	○	○	○	○	○	○	○	○	○	○	○	○
Doll	○	○	○	○	○	○	○	○	○	○	○	○	○
Mammal	○	○	○	○	○	○	○	○	○	○	○	○	○
Fowl	○	○	○	○	○	○	○	○	○	○	○	○	○
Reptile	○	○	○	○	○	○	○	○	○	○	○	○	○
Amphibian	○	○	○	○	○	○	○	○	○	○	○	○	○
Fish	○	○	○	○	○	○	○	○	○	○	○	○	○
Insect	○	○	○	○	○	○	○	○	○	○	○	○	○
Plant	○	○	○	○	○	○	○	○	○	○	○	○	○
Machine	○	○	○	○	○	○	○	○	○	○	○	○	○
Building	○	○	○	○	○	○	○	○	○	○	○	○	○
Tool	○	○	○	○	○	○	○	○	○	○	○	○	○
Other elements	○	○	○	○	○	○	○	○	○	○	○	○	○

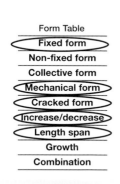

Form Table

- Fixed form
- Non-fixed form
- Collective form
- Mechanical form
- Cracked form
- Increase/decrease
- Length span
- Growth
- Combination

○ giraffe x ostrich x snake x tree

☆ none

❏ This creature is a phantom beast that moves forward using its sole leg and tail. It has stable strength; hence, it is useful for long rides. It reaches for its food by stretching its neck.

Desire to ride on a phantom beast

If one would go on a long trip, he/she would want to ride on a phantom beast that has stable strength and could run fast. This charming creation is based on a fast-running ostrich.

○ ostrich x donkey x hippopotamus + deer's antlers + chicken's crest
☆ none
❏ A boy and a phantom beast go on a long trip. The phantom beast does not need to be fed for a long time because it has stable strength, like a camel. It can turn its neck one hundred eighty degrees and is a fast runner.

Creative adaptation of the four natural elements: (clockwise from top left) wind, fire, earth, and water

Fairies and Spirits

Fairies and Spirits

Fairies and spirits are personifications of natural phenomena or of the energy and vitality of the universe.

Since ancient times, people have believed that every form of life in the natural world possesses a spirit and that fairies embody the natural elements. There are countless forms of fairies, such as personified figures of males, females, old men, children, asexual creatures, animals, plants, insects, and so on. They also have a variety of personalities-gentle, mischievous, cunning, hot-tempered, etc.-but they do not have a sense of morality. They are also known to be embodiments of capricious nature.

Fairies as embodiments of the natural elements
■ Four Natural Elements
All matter in this world consists of four basic elements: earth, wind, fire, and water. In 16th-century Europe, the alchemist Paracelsus defined fairies as representing each.

Salamander, spirit of fire
This spirit lives inside lava. Lizard-like, it is tiny and can rest on one's palm.

Sylph, spirit of air
Sylph lives in forests and flies, making sounds with the trees.

Undine, spirit of water
Beautiful Undine lives in lakes or fountains. She often falls in love with a human.

Gnome, the spirit of earth
Gnome lives underground and looks elderly. It creates excellent craft items.

Interactions between humans and fairies in the natural world
■ Fairies that play tricks on humans
Example: pixie

Pixies have wings and are tiny. They love dancing, especially in a circle at night when the crickets start to sing. When travelers step into the forest, they play tricks on them.

■ Fairies that enchant humans
Example: elf

These fairies are described as beautiful, with long pointed ears. They enchant anyone they encounter and lead them to their kingdom. Once caught in their spell, people can no longer return to their world.

Free Creation (Designing fairies and spirits)
Knowing the Fairies and Spirits You Want to Create

It is possible to create fairies and spirits by combining body parts. This section introduces the method of body combination.

The keywords for creating fairies and spirits are such factors as size (big or small), texture (hard or soft), and the elements of the universe.

Study 1: big or small
Study 2: personification or monster transformation
Study 3: incorporation of nature's essential elements

Fairies and spirits do not have tangible forms; hence, their body sizes can be set up freely.

Example: dirt and rocks incorporated in the earth spirit's body

Form Table

- Fixed form
- Non-fixed form
- Collective form
- Mechanical form
- Cracked form
- Increase/decrease
- Length span
- Growth
- Combination

	Human being	Doll	Mammal	Fowl	Reptile	Amphibian	Fish	Insect	Plant	Machine	Building	Tool	Other elements
Human being													O
Doll													O
Mammal													O
Fowl													O
Reptile													O
Amphibian													O
Fish													O
Insect													O
Plant													O
Machine													O
Building													O
Tool													O
Other elements	O	O	O	O	O	O	O	O	O	O	O	O	O

Fairies from the Natural World
Encountering such fairies

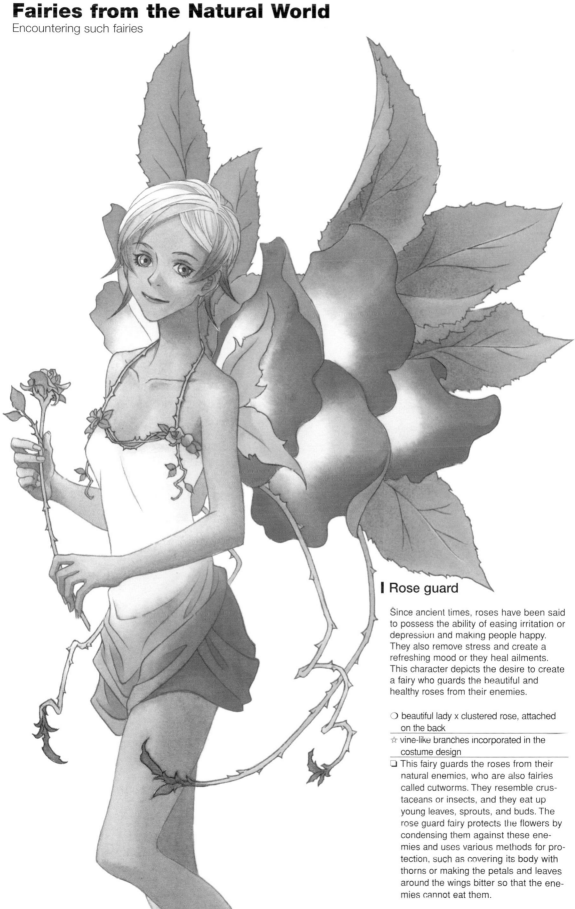

Rose guard

Since ancient times, roses have been said to possess the ability of easing irritation or depression and making people happy. They also remove stress and create a refreshing mood or they heal ailments. This character depicts the desire to create a fairy who guards the beautiful and healthy roses from their enemies.

○ beautiful lady x clustered rose, attached on the back

☆ vine-like branches incorporated in the costume design

❏ This fairy guards the roses from their natural enemies, who are also fairies called cutworms. They resemble crustaceans or insects, and they eat up young leaves, sprouts, and buds. The rose guard fairy protects the flowers by condensing them against these enemies and uses various methods for protection, such as covering its body with thorns or making the petals and leaves around the wings bitter so that the enemies cannot eat them.

Mermaid

This character is created from the popular childhood tale, *The Little Mermaid*. It would be desirable to hear her singing if she actually exists.

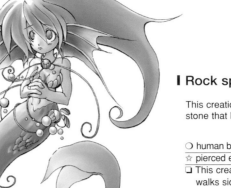

○ girl x fish
☆ shell, pearl
❏ This beautiful mermaid is partly fish and partly human. She sits on the ocean rock and sings with her sweet, seductive voice. People who hear her sing are enchanted, jump into the sea, and drown.

Forest dwarf fairies

This character is created from the desire to encounter a fairy in the forest, such as a small animal that rests on one's palm.

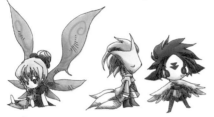

○ dwarf x type of small animal
☆ none
❏ Dwarf fairies that live in the forest are so small that they can rest on one's palm.

Rock spirit

This creation is modeled after a stone that looks like a human face.

○ human being x rock
☆ pierced earrings
❏ This creature is a rock man who walks sideways like a crab and has the ability to petrify other creatures by looking at them.

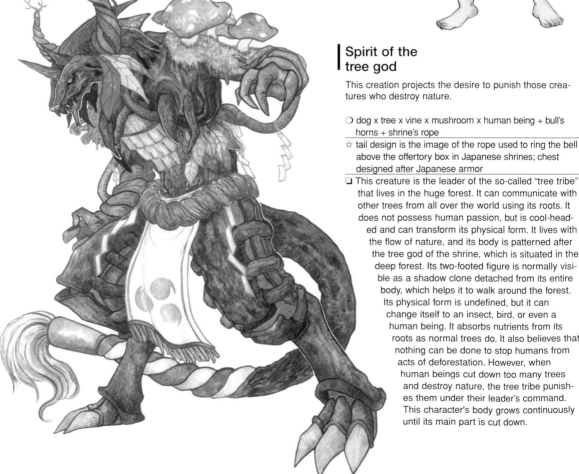

Spirit of the tree god

This creation projects the desire to punish those creatures who destroy nature.

○ dog x tree x vine x mushroom x human being + bull's horns + shrine's rope
☆ tail design is the image of the rope used to ring the bell above the offertory box in Japanese shrines; chest designed after Japanese armor
❏ This creature is the leader of the so-called "tree tribe" that lives in the huge forest. It can communicate with other trees from all over the world using its roots. It does not possess human passion, but is cool-headed and can transform its physical form. It lives with the flow of nature, and its body is patterned after the tree god of the shrine, which is situated in the deep forest. Its two-footed figure is normally visible as a shadow clone detached from its entire body, which helps it to walk around the forest. Its physical form is undefined, but it can change itself to an insect, bird, or even a human being. It absorbs nutrients from its roots as normal trees do. It also believes that nothing can be done to stop humans from acts of deforestation. However, when human beings cut down too many trees and destroy nature, the tree tribe punishes them under their leader's command. This character's body grows continuously until its main part is cut down.

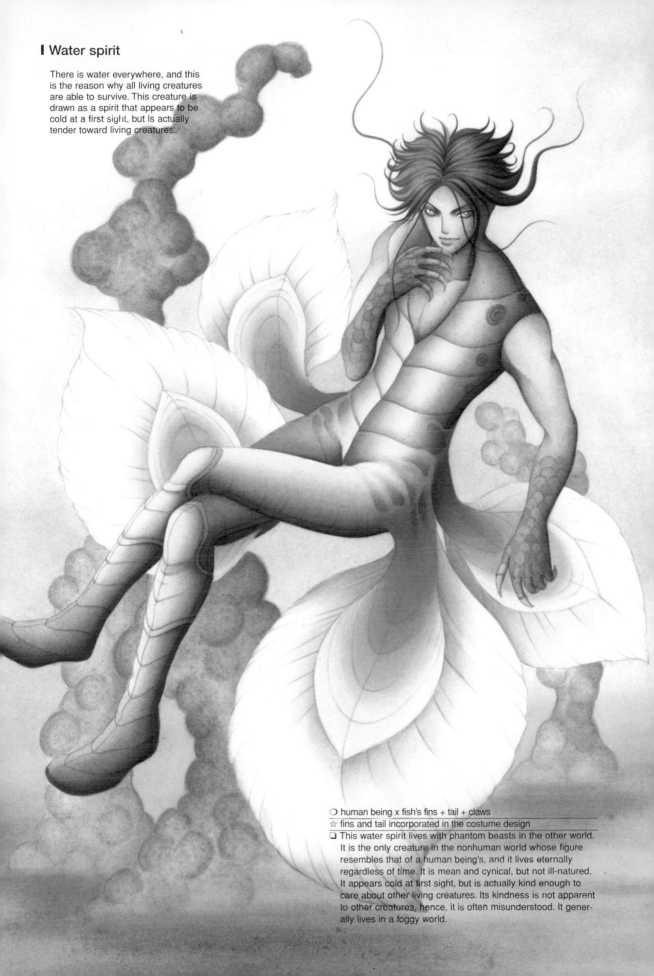

▌Water spirit

There is water everywhere, and this
is the reason why all living creatures
are able to survive. This creature is
drawn as a spirit that appears to be
cold at a first sight, but is actually
tender toward living creatures.

○ human being x fish's fins + tail + claws
☆ fins and tail incorporated in the costume design
❏ This water spirit lives with phantom beasts in the other world.
It is the only creature in the nonhuman world whose figure
resembles that of a human being's, and it lives eternally
regardless of time. It is mean and cynical, but not ill-natured.
It appears cold at first sight, but is actually kind enough to
care about other living creatures. Its kindness is not apparent
to other creatures, hence, it is often misunderstood. It gener-
ally lives in a foggy world.

Forming Spirits from Nature's Four Elements

Imagining the presence of these spirits

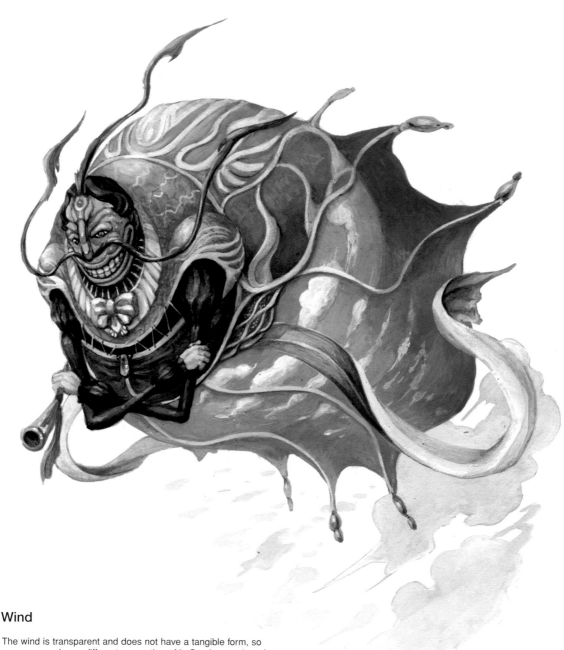

❚ Wind

The wind is transparent and does not have a tangible form, so every person has a different perception of it. One impression of it is that it blows leaves, clouds in the sky, or balloons floating in the air. The wind is so capricious that people do not know when it blows. This creation is an imaginary figure of a spirit that could control the wind.

○ witch + circus leader + balloon + sky

☆ combination of circus leader attire and a balloon; a mustache; and a soft piece of cloth blowing in the air to produce a windy effect; holds a trumpet

❏ The wind is personified in this spirit and carries itself inside its body. It makes a trumpet sound from the treetops. After it passes by while playing the trumpet, the buds come out of the seeds. It also has the power to generate life.

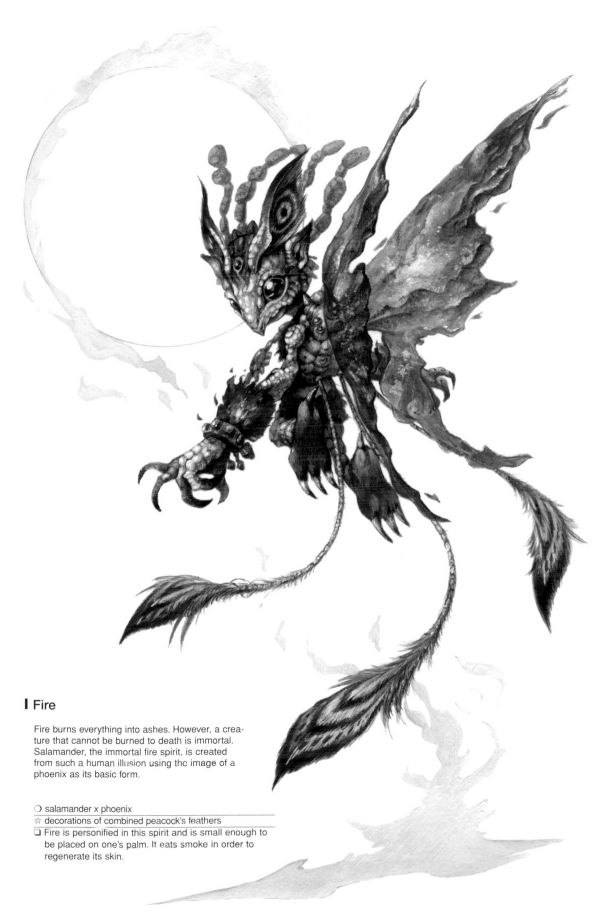

❙ Fire

Fire burns everything into ashes. However, a creature that cannot be burned to death is immortal. Salamander, the immortal fire spirit, is created from such a human illusion using the image of a phoenix as its basic form.

○ salamander x phoenix

☆ decorations of combined peacock's feathers

❏ Fire is personified in this spirit and is small enough to be placed on one's palm. It eats smoke in order to regenerate its skin.

Water

Water produces a variety of sounds, such as the sound of the rain, the song of a river, or the roar of the waves. Lives are cradled in the water planet and in the earth. Human beings are also cradled in the mother's amniotic fluid. The sound of water is the sound of the earth and, therefore, the sound of life. This creation projects the following chain of ideas: sound of water, earth, heartbeat, goddess, and a spirit that plays the harp.

○ water x goddess x harp

☆ water incorporated in the costume design

❏ The water goddess is the source of all life. Water can be harmful or graceful to human beings depending on the sound intensity of the harp that she plays. All forces of life depend on the goddess' will.

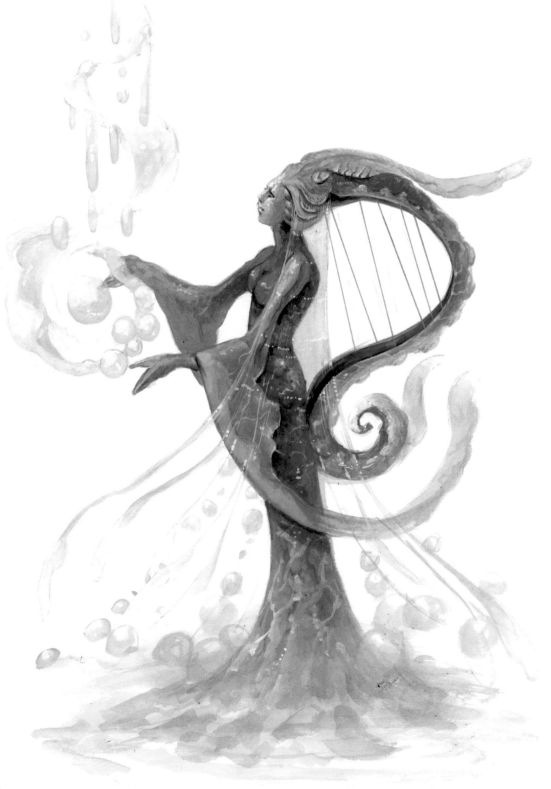

Earth

Earth is a form of blessing from Mother Nature that maintains the lives of animals and plants. The plants on this earth grow roots and take up minerals that exist in the soil as forms of nutrition. Animals are also blessings from Mother Nature by eating plants to make them grow. If the earth spirit exists in the real world, it would be a huge and robust multiformed beast that is gentle toward living creatures. This creation illustrates the following chain of ideas: earth, land, rock, moss, and a huge, strong, and vigorous multiformed spirit.

○ rock x bulldog x gorilla + tulip's tail + horns

☆ carpet

❏ This spirit is huge, robust, and administers the earth. It is gentle toward all the living creatures on the earth. Plants grow from its body to receive blessings from Mother Nature.

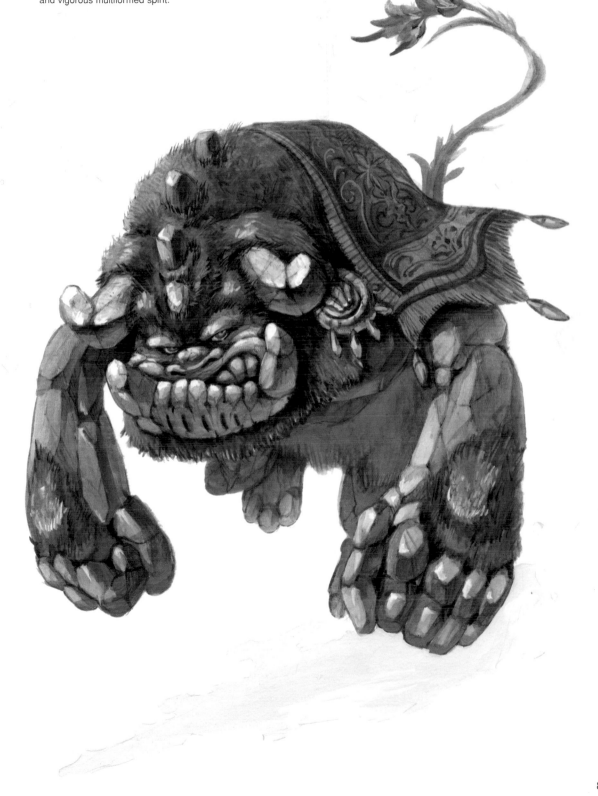

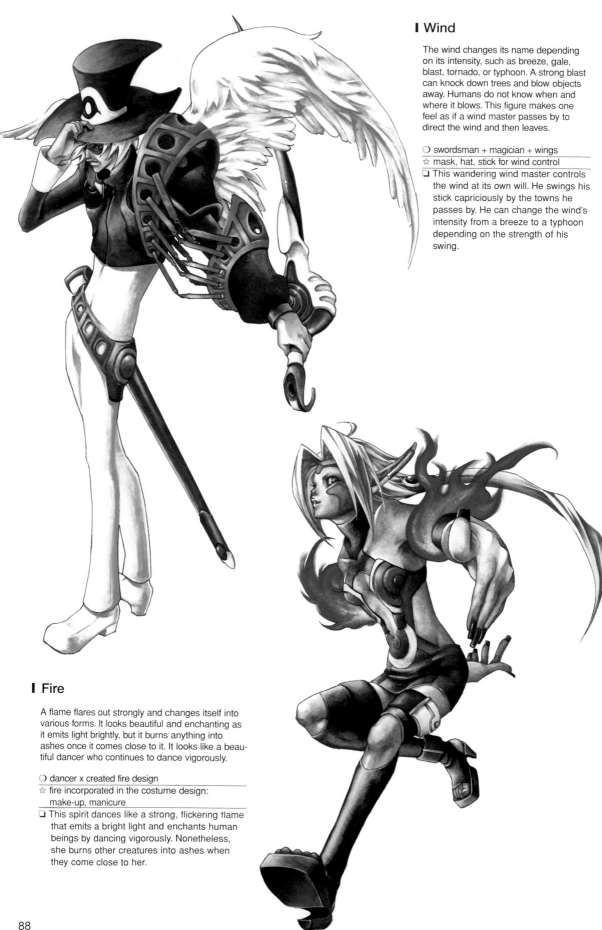

Wind

The wind changes its name depending on its intensity, such as breeze, gale, blast, tornado, or typhoon. A strong blast can knock down trees and blow objects away. Humans do not know when and where it blows. This figure makes one feel as if a wind master passes by to direct the wind and then leaves.

○ swordsman + magician + wings
☆ mask, hat, stick for wind control
❑ This wandering wind master controls the wind at its own will. He swings his stick capriciously by the towns he passes by. He can change the wind's intensity from a breeze to a typhoon depending on the strength of his swing.

Fire

A flame flares out strongly and changes itself into various forms. It looks beautiful and enchanting as it emits light brightly, but it burns anything into ashes once it comes close to it. It looks like a beautiful dancer who continues to dance vigorously.

○ dancer x created fire design
☆ fire incorporated in the costume design: make-up, manicure
❑ This spirit dances like a strong, flickering flame that emits a bright light and enchants human beings by dancing vigorously. Nonetheless, she burns other creatures into ashes when they come close to her.

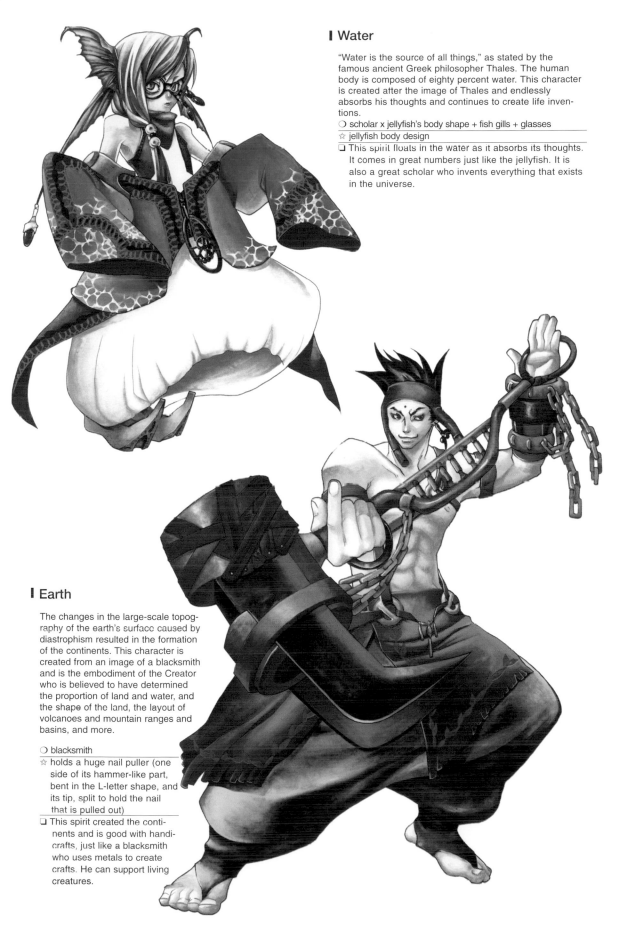

▌Water

"Water is the source of all things," as stated by the famous ancient Greek philosopher Thales. The human body is composed of eighty percent water. This character is created after the image of Thales and endlessly absorbs his thoughts and continues to create life inventions.

○ scholar x jellyfish's body shape + fish gills + glasses

☆ jellyfish body design

❏ This spirit floats in the water as it absorbs its thoughts. It comes in great numbers just like the jellyfish. It is also a great scholar who invents everything that exists in the universe.

▌Earth

The changes in the large-scale topography of the earth's surface caused by diastrophism resulted in the formation of the continents. This character is created from an image of a blacksmith and is the embodiment of the Creator who is believed to have determined the proportion of land and water, and the shape of the land, the layout of volcanoes and mountain ranges and basins, and more.

○ blacksmith

☆ holds a huge nail puller (one side of its hammer-like part, bent in the L-letter shape, and its tip, split to hold the nail that is pulled out)

❏ This spirit created the continents and is good with handicrafts, just like a blacksmith who uses metals to create crafts. He can support living creatures.

The earth goddess creating the world in her open hands as she imagines the creation process

Creatures in the Artificial World

Creatures in the Artificial World

Artificial life refers to elements created by man-made systems, such as computers.

Cyborgs
Cyborgs are bodies of living creatures combined with transplanted machineries, which adjust and control their functions.

Androids
Androids are similar to human beings in their appearances and in their thoughts and behavior. Their forms are mechanized human bodies.

Robots
Robots are machines that are operated automatically by computers to induce complex movements.

The creatures of the artificial world include cyborgs, androids, and robots. Creative thinking for science fiction and the ability to interpret things are indispensable for writing stories set in the future. A machine and a beautiful lady, or a robot and a boy, are some popular artificial character combinations.

Free Creation (Designing creatures of the artificial world)
Knowing the Artificial Creature You Want to Create

Form Table
Fixed form
Non-fixed form
Collective form
Mechanical form
Cracked form
Increase/decrease
Length span
Growth
Combination

Cyborgs:
Combining mechanized parts or partial body components

Androids:
Mechanizing the entire human or non-human body

Robots:
Changing the body into a precision instrument

	Human being	Doll	Mammal	Fowl	Reptile	Amphibian	Fish	Insect	Plant	Machine	Building	Tool	Other elements
Human being										O	O	O	O
Doll										O	O	O	O
Mammal										O	O	O	O
Fowl										O	O	O	O
Reptile										O	O	O	O
Amphibian										O	O	O	O
Fish										O	O	O	O
Insect										O	O	O	O
Plant										O	O	O	O
Machine	O	O	O	O	O	O	O	O	O	O	O	O	O
Building	O	O	O	O	O	O	O	O	O	O	O	O	O
Tool	O	O	O	O	O	O	O	O	O	O	O	O	O
Other elements	O	O	O	O	O	O	O	O	O	O	O	O	O

Cyborgs
The most frequently used components for cyborg creation are artificial composites, such as tubes, pipes, wiring, springs, and semiconductors; repairing tools, such as screws, nails, etc.; and medical instruments, such as artificial arms and legs.

Robots
Mechanizing a character based on a living creature's body
You can design a robot's body based on various types of living creatures.

Cyborgs and Androids

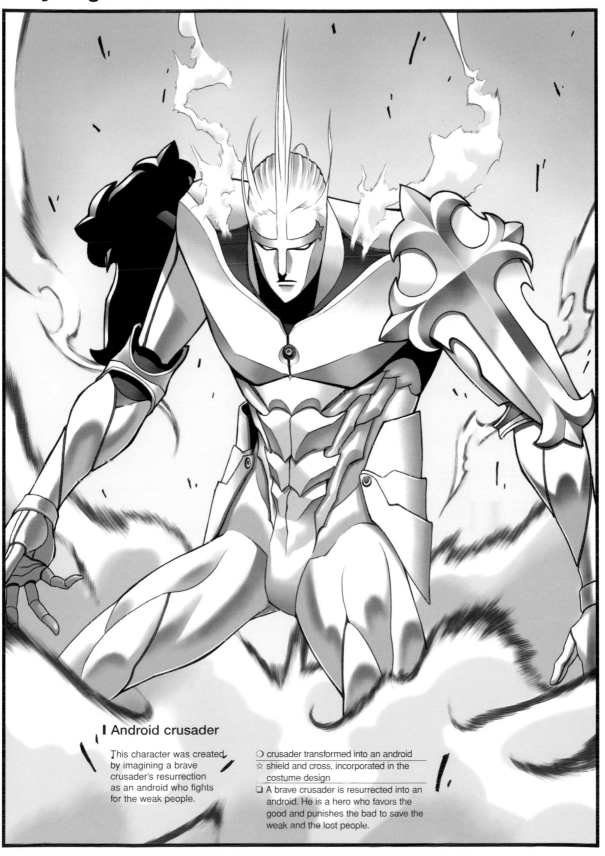

Android crusader

This character was created by imagining a brave crusader's resurrection as an android who fights for the weak people.

○ crusader transformed into an android

☆ shield and cross, incorporated in the costume design

❏ A brave crusader is resurrected into an android. He is a hero who favors the good and punishes the bad to save the weak and the lost people.

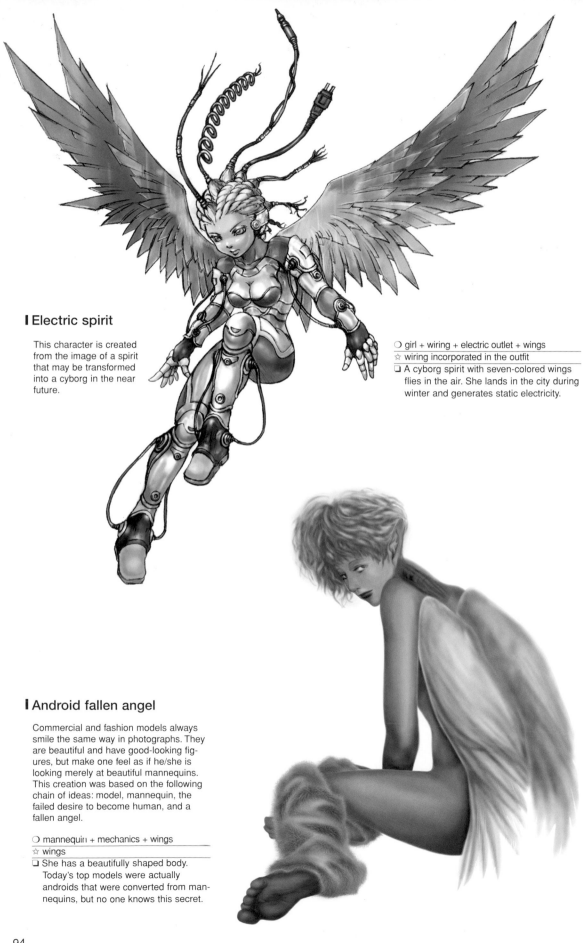

▌Electric spirit

This character is created from the image of a spirit that may be transformed into a cyborg in the near future.

○ girl + wiring + electric outlet + wings
☆ wiring incorporated in the outfit
❏ A cyborg spirit with seven-colored wings flies in the air. She lands in the city during winter and generates static electricity.

▌Android fallen angel

Commercial and fashion models always smile the same way in photographs. They are beautiful and have good-looking figures, but make one feel as if he/she is looking merely at beautiful mannequins. This creation was based on the following chain of ideas: model, mannequin, the failed desire to become human, and a fallen angel.

○ mannequin + mechanics + wings
☆ wings
❏ She has a beautifully shaped body. Today's top models were actually androids that were converted from mannequins, but no one knows this secret.

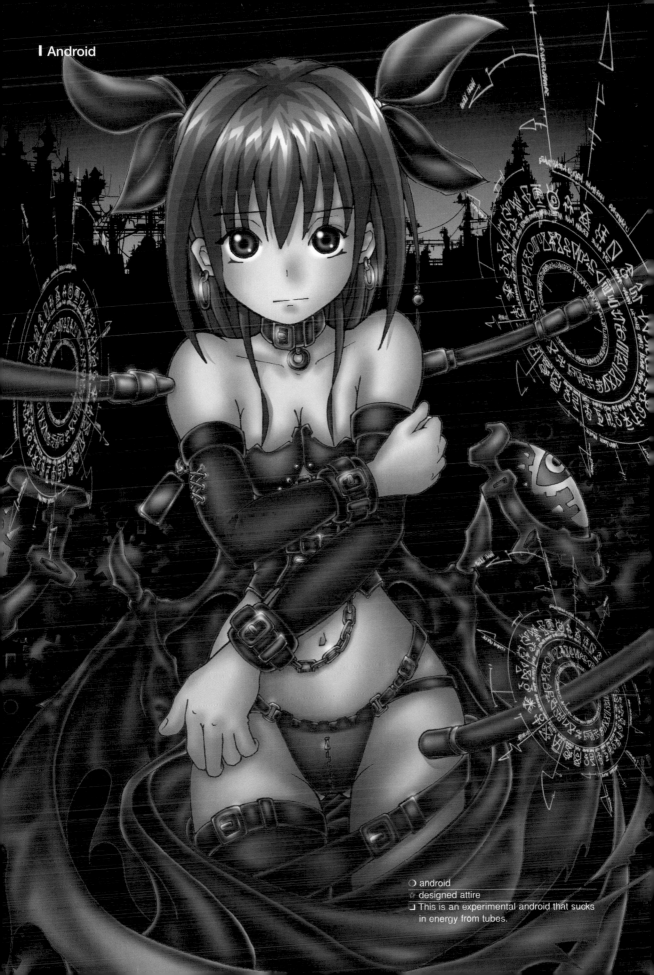

○ android
☆ designed attire
❑ This is an experimental android that sucks
 in energy from tubes.

Robots

Hard-working robots
Pill bug robots

One can imagine the fun of seeing robots working and living closely together with human beings in future cities. These characters are created based on insect-body forms that work hard for human beings.

○ pill bug-shaped robot

☆ design based on a pill bug's bodily shape

❏ In this illustration, the small robot seen between the two hands of the bigger robot enters its head and operates it. It moves only when necessary.

Long-horned beetle-shaped robot

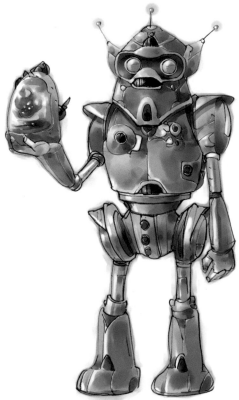

Beetle robot

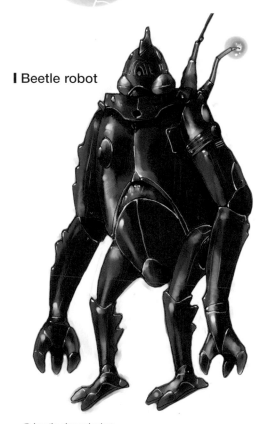

○ long-horned beetle-shaped robot

☆ bodily shape of a long-horned beetle; holds an aquarium containing goldfish

❏ This robot is a goldfish vendor who walks around during festivals in the future world.

○ beetle-shaped robot

☆ bodily shape of a beetle

❏ This is a robot developed for carrying cargo equipment. Its claws can reach high places.

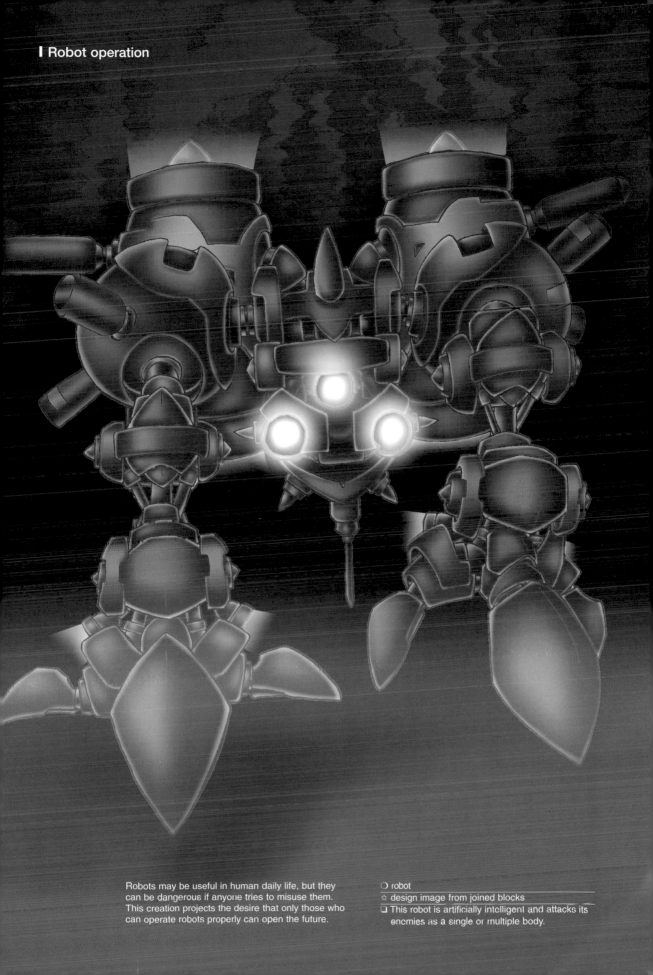

▌Robot operation

Robots may be useful in human daily life, but they can be dangerous if anyone tries to misuse them. This creation projects the desire that only those who can operate robots properly can open the future.

○ robot
☆ design image from joined blocks
❏ This robot is artificially intelligent and attacks its enemies as a single or multiple body.

Interplanetary Mechanical Beings
from Science Fiction

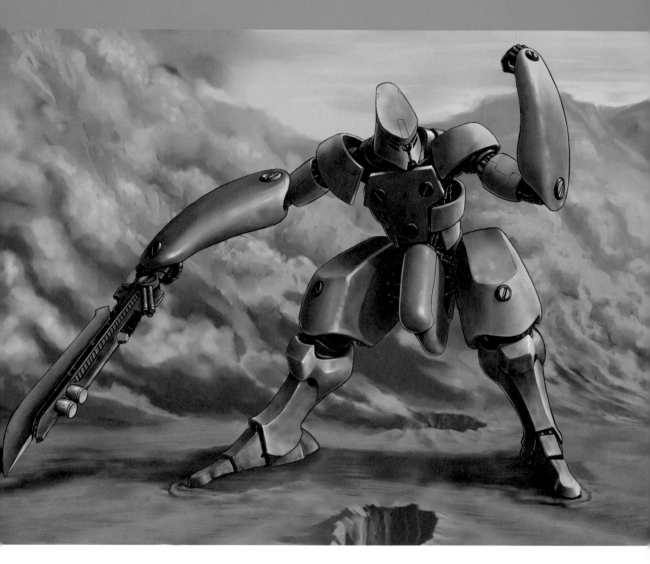

Imagining living creatures as mechanized robots

The inhabitants on the mechanical planet have started to reconstruct their kingdom since they succeeded in developing the life support system. At present, they have mechanized ninety percent of all existing elements on the planet, transforming their own bodies into machines, overcoming their fear of death. Moreover, they have created an artificial sun and controlled the natural phenomena by making ultimate use of their super scientific knowledge. The mechanical planet will never perish and will continue to exist in the cosmic space. This is one of the revolutionary paths that the inhabitants have chosen to obtain highly scientific capabilities.

However, one fundamental problem is that human beings are the only creatures who hate and kill each other. Since they obtained mechanical bodies, they have been armed and have fought over one another's superiority. Some people wish to conquer the world by creating fictitious robots, such as gods, angels, devils, monsters, and spirits. What would be the definition of "living creatures" in this sense? One may discover it by landing on the mechanical planet.

❚ Horseman robots

○ knight x assembled machinery

☆ mechanized horseman robot with creative variations
 of armor shapes and defensive tools

❏ This illustration shows the present forms of the native inhabi-
 tants who reconstructed the mechanical planet. They attack
 the same types of robots, and they believe that they are
 stronger than any other robot.

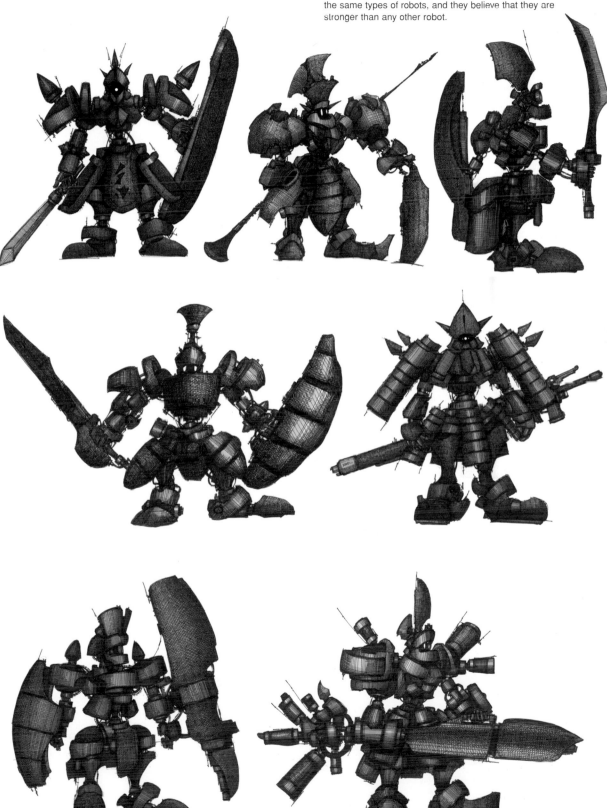

❙ Insect robots

○ insect or invertebrate x assembled machinery
☆ mechanized body parts
❏ These robots were mechanized from insects or invertebrates, and some were transformed during the course of their growth. They lost their reproductive abilities and merely fly around in the air endlessly.

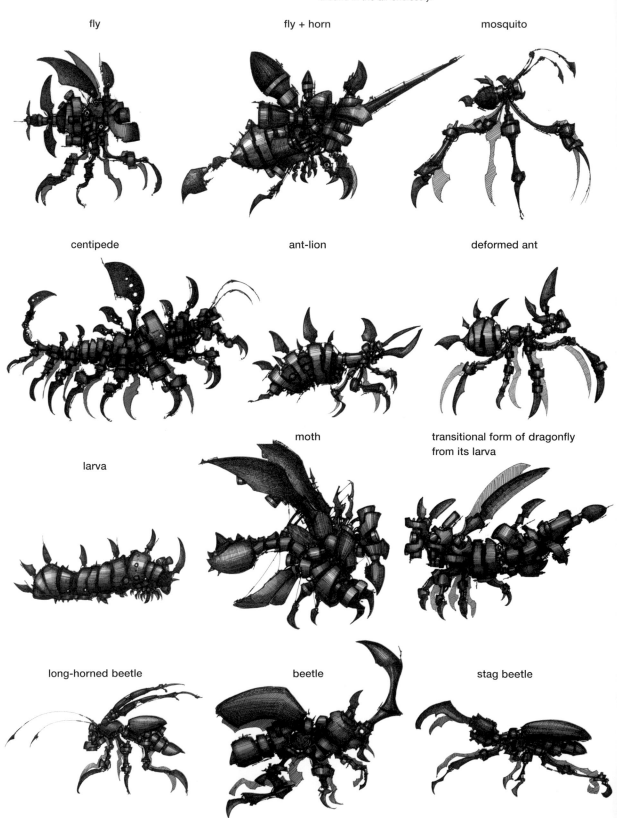

fly

fly + horn

mosquito

centipede

ant-lion

deformed ant

larva

moth

transitional form of dragonfly from its larva

long-horned beetle

beetle

stag beetle

Underwater robot creatures

○ aquatic creature x assembled machinery
☆ mechanized body parts
❏ These robots were mechanized as underwater robot creatures. They lost their reproductive abilities and merely float in the water endlessly.

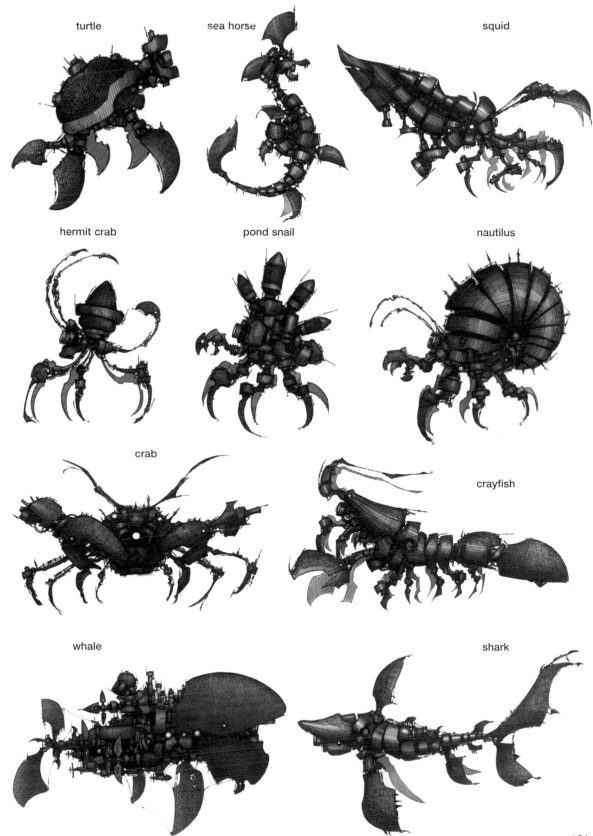

turtle

sea horse

squid

hermit crab

pond snail

nautilus

crab

crayfish

whale

shark

❙ Dragon and devil robots

○ dragon or devil x assembled machinery
☆ mechanized body parts
❏ These robots were mechanized from dragons and devils, which are the evil symbols in Greek mythology and in the Bible. They have the strongest power to destroy other robots that disturb them and were created by people who intend to conquer the world.

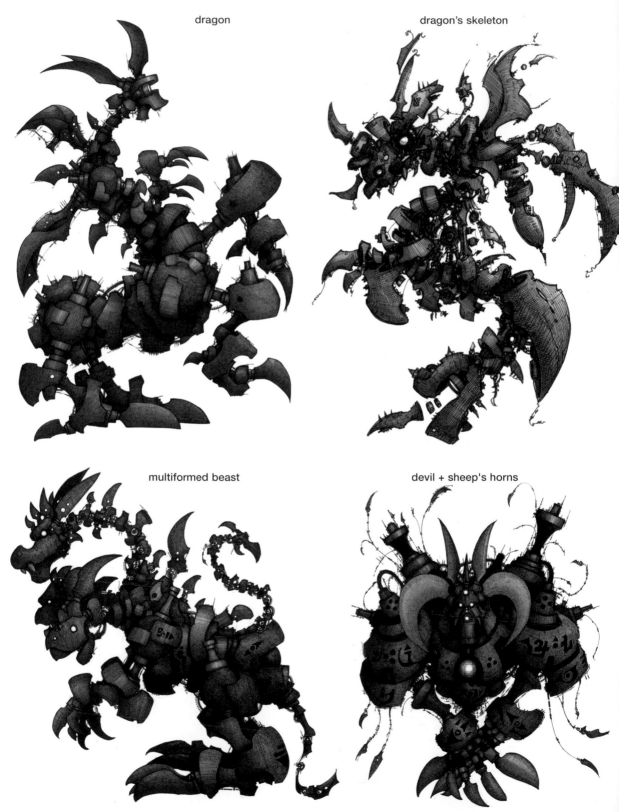

dragon

dragon's skeleton

multiformed beast

devil + sheep's horns

Mobile castle robots

○ castle x hermit crab x assembled machinery

☆ mechanized castle

❏ The castle robot was mechanized to prevent sudden attacks or invasions from enemies. If the castle master calls for it, it runs fast toward the master. Some insect robots live in it as parasites.

A violent panda is transformed into a monster, using its sharp claws and a bamboo tip to attack its enemies

Monsters

Monsters

Monsters can be defined as:

1. creatures whose bodies are transformed from human bodies
2. violent creatures that have dangerous objects installed in human bodies
3. deformed creatures created by the fusion of different violent creatures
4. creatures dominated by parasitical violent creatures
5. creatures possessed by an evil spirit

Fallen angels, devils, and monsters represent darkness and evil. There are stories of monsters from all over the world. There are basically two types: those that are born to be monsters and those that are deformed into monsters because of their lust.

Stories about the birth of monsters

■ Myths and religions

Demon

A demon is a very powerful monster with two horns. In some folklore stories, when normal people have strong grudges they are transformed into demons.

■ Occultism

Zombie

Zombies are monsters who have dead bodies revived by sorcerers who can control them at will. Voodoo superstitions claim that those who commit a crime will be transformed into zombies.

Vampire

Vampires are monsters that resurrect from their graves and attack people at night living on their blood. Count Dracula was a vampire.

Free Creation (Designing monsters)
Knowing the Type of Monster You Want to Create

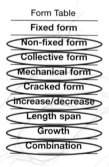

Form Table
Fixed form
Non-fixed form
Collective form
Mechanical form
Cracked form
increase/decrease
Length span
Growth
Combination

There is no restriction in designing monsters' forms. One can imagine many frightening combinations.

We feel frightened when we find a creature with an unfamiliar physique.

Fear creation through unfamiliar impressions

1. increasing the number of components
2. deforming body parts
3. growing elements from the body

Fear creation through dangerous impressions

1. combining sharp materials, such as fangs, claws, etc.
2. showing blood or fluid
3. extending the tongue

Fear creation from personal experience

What makes one scared or frightened? People who as children thought that birds were cute may be frightened of them after having gone through a fearful experience with them. Discover what causes fear, then choose an appropriate body and parts.

	Human being	Doll	Mammal	Fowl	Reptile	Amphibian	Fish	Insect	Plant	Machine	Building	Tool
Horn	O	O	O	O	O	O	O	O	O	O	O	O
Ear	O	O	O	O	O	O	O	O	O	O	O	O
Eye	O	O	O	O	O	O	O	O	O	O	O	O
Fang	O	O	O	O	O	O	O	O	O	O	O	O
Tongue	O	O	O	O	O	O	O	O	O	O	O	O
Wings	O	O	O	O	O	O	O	O	O	O	O	O
Tail	O	O	O	O	O	O	O	O	O	O	O	O
Claw	O	O	O	O	O	O	O	O	O	O	O	O
Skin	O	O	O	O	O	O	O	O	O	O	O	O
Scissors	O	O	O	O	O	O	O	O	O	O	O	O

	Human being	Doll	Mammal	Fowl	Reptile	Amphibian	Fish	Insect	Plant	Machine	Building	Tool	Other elements
Human being	O	O	O	O	O	O	O	O	O	O	O	O	O
Doll	O	O	O	O	O	O	O	O	O	O	O	O	O
Mammal	O	O	O	O	O	O	O	O	O	O	O	O	O
Fowl	O	O	O	O	O	O	O	O	O	O	O	O	O
Reptile	O	O	O	O	O	O	O	O	O	O	O	O	O
Amphibian	O	O	O	O	O	O	O	O	O	O	O	O	O
Fish	O	O	O	O	O	O	O	O	O	O	O	O	O
Insect	O	O	O	O	O	O	O	O	O	O	O	O	O
Plant	O	O	O	O	O	O	O	O	O	O	O	O	O
Machine	O	O	O	O	O	O	O	O	O	O	O	O	O
Building	O	O	O	O	O	O	O	O	O	O	O	O	O
Tool	O	O	O	O	O	O	O	O	O	O	O	O	O
Other elements	O	O	O	O	O	O	O	O	O	O	O	O	O

Demons and Devils

Imagining the presence of these monsters

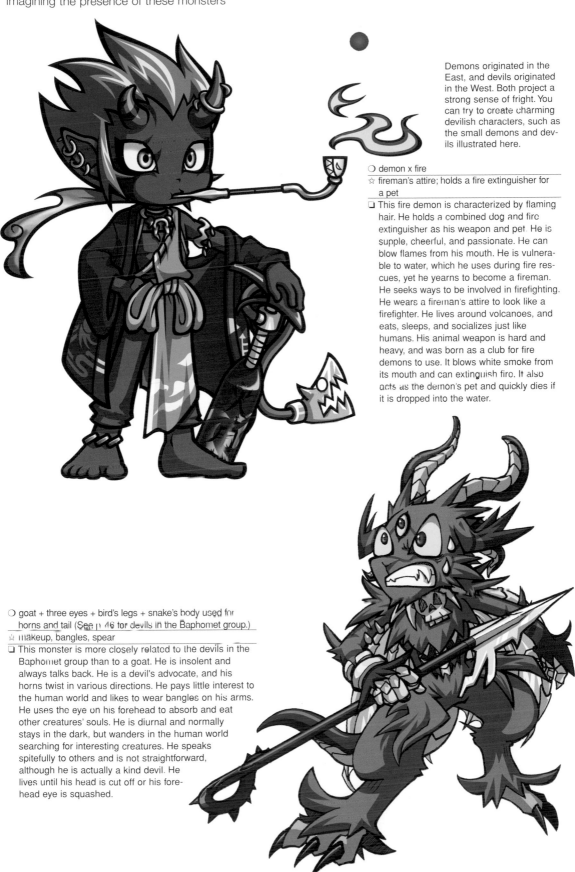

Demons originated in the East, and devils originated in the West. Both project a strong sense of fright. You can try to create charming devilish characters, such as the small demons and devils illustrated here.

○ demon x fire

☆ fireman's attire; holds a fire extinguisher for a pet

❏ This fire demon is characterized by flaming hair. He holds a combined dog and fire extinguisher as his weapon and pet. He is supple, cheerful, and passionate. He can blow flames from his mouth. He is vulnerable to water, which he uses during fire rescues, yet he yearns to become a fireman. He seeks ways to be involved in firefighting. He wears a fireman's attire to look like a firefighter. He lives around volcanoes, and eats, sleeps, and socializes just like humans. His animal weapon is hard and heavy, and was born as a club for fire demons to use. It blows white smoke from its mouth and can extinguish fire. It also acts as the demon's pet and quickly dies if it is dropped into the water.

○ goat + three eyes + bird's legs + snake's body used for horns and tail (See p. 46 for devils in the Baphomet group.)

☆ makeup, bangles, spear

❏ This monster is more closely related to the devils in the Baphomet group than to a goat. He is insolent and always talks back. He is a devil's advocate, and his horns twist in various directions. He pays little interest to the human world and likes to wear bangles on his arms. He uses the eye on his forehead to absorb and eat other creatures' souls. He is diurnal and normally stays in the dark, but wanders in the human world searching for interesting creatures. He speaks spitefully to others and is not straightforward, although he is actually a kind devil. He lives until his head is cut off or his forehead eye is squashed.

Souls and Dead Bodies
Imagining dead creatures to resurrect

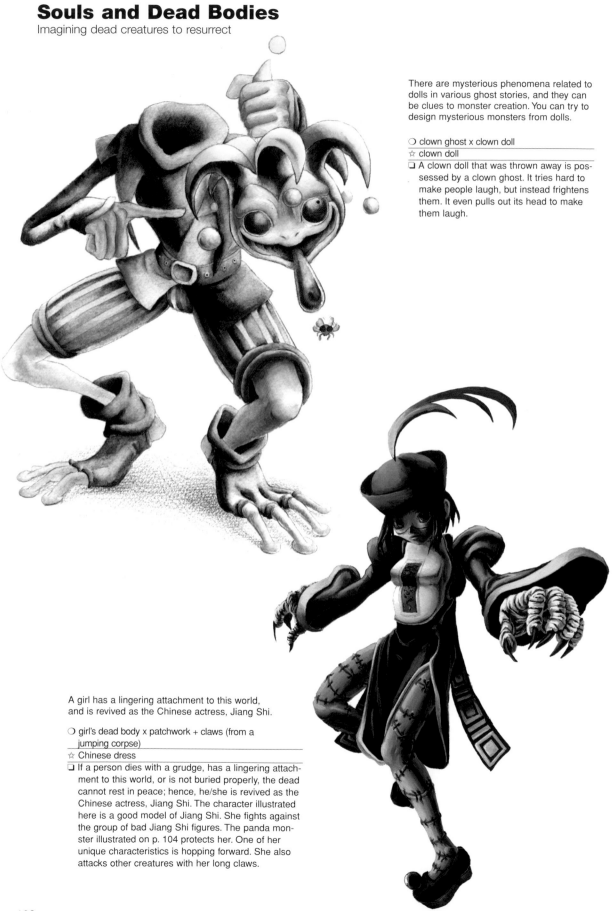

There are mysterious phenomena related to dolls in various ghost stories, and they can be clues to monster creation. You can try to design mysterious monsters from dolls.

○ clown ghost x clown doll

☆ clown doll

❏ A clown doll that was thrown away is possessed by a clown ghost. It tries hard to make people laugh, but instead frightens them. It even pulls out its head to make them laugh.

A girl has a lingering attachment to this world, and is revived as the Chinese actress, Jiang Shi.

○ girl's dead body x patchwork + claws (from a jumping corpse)

☆ Chinese dress

❏ If a person dies with a grudge, has a lingering attachment to this world, or is not buried properly, the dead cannot rest in peace; hence, he/she is revived as the Chinese actress, Jiang Shi. The character illustrated here is a good model of Jiang Shi. She fights against the group of bad Jiang Shi figures. The panda monster illustrated on p. 104 protects her. One of her unique characteristics is hopping forward. She also attacks other creatures with her long claws.

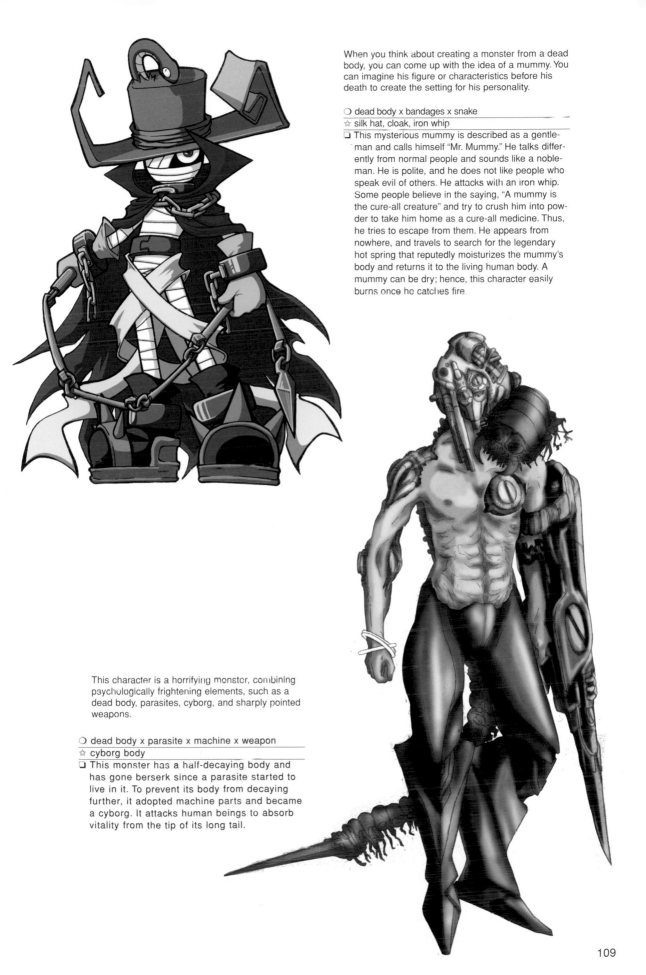

When you think about creating a monster from a dead body, you can come up with the idea of a mummy. You can imagine his figure or characteristics before his death to create the setting for his personality.

○ dead body x bandages x snake
☆ silk hat, cloak, iron whip
❏ This mysterious mummy is described as a gentleman and calls himself "Mr. Mummy." He talks differently from normal people and sounds like a nobleman. He is polite, and he does not like people who speak evil of others. He attacks with an iron whip. Some people believe in the saying, "A mummy is the cure-all creature" and try to crush him into powder to take him home as a cure-all medicine. Thus, he tries to escape from them. He appears from nowhere, and travels to search for the legendary hot spring that reputedly moisturizes the mummy's body and returns it to the living human body. A mummy can be dry; hence, this character easily burns once he catches fire.

This character is a horrifying monster, combining psychologically frightening elements, such as a dead body, parasites, cyborg, and sharply pointed weapons.

○ dead body x parasite x machine x weapon
☆ cyborg body
❏ This monster has a half-decaying body and has gone berserk since a parasite started to live in it. To prevent its body from decaying further, it adopted machine parts and became a cyborg. It attacks human beings to absorb vitality from the tip of its long tail.

Deformed Monsters
Imagining crazy monsters

This character is a monster that eats any living creature to boost its power. To create this image, you can start drawing motifs of psychologically fearful elements, such as spiders, birds, carnivorous plants, and arrowheads. The character can look more violent by adding parts, such as horns and claws.

○ dog x bird x spider x arrowhead

☆ sharp claws

❏ This monster is created as a soldier and is not as intelligent as human beings. It lives with an animal's instinct and obeys its master. It has an overwhelmingly destructive power and unlimited stamina. It attacks other creatures with its arrowhead-like hair and sharp claws. It can crush a rock with its fists, and can grab other creatures and eat them from its mouth, which is located in its chest. It can also master other creatures' abilities. It is diurnal, and is kept inside a cage except when it goes out to fight. It is carnivorous, and when it is not fed enough, it satisfies its appetite by fighting enemies. It dislikes fire and has a big appetite all year around.

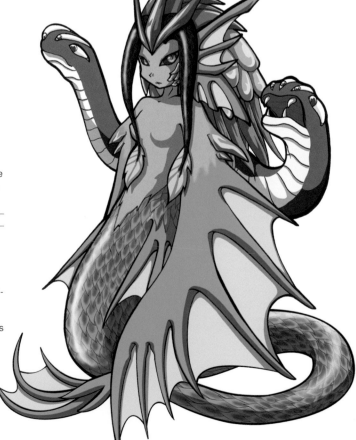

This character is created from the desire to draw a female figure from the devil's tribe. As a mermaid transformed into a violent creature with two combined sea snakes on its back, this character's image is completely opposite from that of familiar mermaids.

○ woman x fish x two snakes

☆ mermaid attire

❏ This mermaid belongs to the aquatic devil's tribe. She has two snakes growing from the back of her head. She is quiet and dislikes noise. She lives under water and on the ground. She can control people whom she stares at with her eyes. She is nocturnal, but wakes up when something approaches her habitat during the day, and she acts quickly to drive it away. She is carnivorous and takes in nutrition for the two snakes as well; hence, she eats three times as much as the other mermaids in the tribe. She can die of shock from intense light. Snakes grow from her head to protect her main body, and they have many eyes to watch in many directions. They regenerate in a few days after being cut off, unless the main body dies. They live with the main body and eat fish or other animals as they wander.

Insects
Imagining crazy insects

The illustrations below show small, yet violent monsters. Mini-monsters can be created from insects.

○ variations of small, armored insect monsters
☆ armors designed like crustacean shells
❏ These small monsters are crazy, armored insects. They have a variety of personalities, such as friendly, lazy, or crybaby, and have special skills, such as biting, stabbing with horns, attacking with poison, and more.

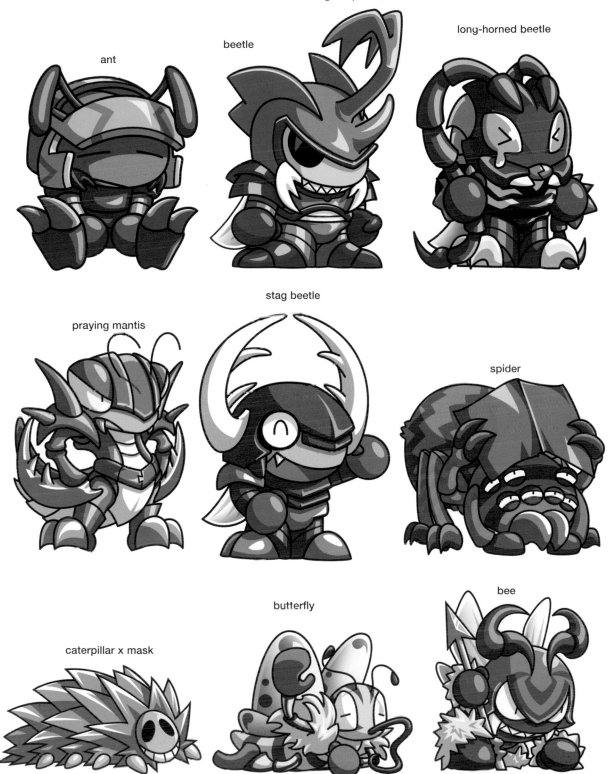

ant

beetle

long-horned beetle

praying mantis

stag beetle

spider

caterpillar x mask

butterfly

bee

Fearful Monsters that Break the Laws of Ecology 1

I Human Blood-sucking Insectivorous Plants

long tongue combination

octopus suckers combination

slime

leaves of insectivorous plant

earthworm combination

Relations with insectivorous plants
Insectivorous plants catch insects and small animals with their leaves and other components, then digest, and absorb them as nutrients. They grow where there is little nutrition, and they also produce their own nutrients by taking in sunlight, just like other ordinary plants do. When they do not eat insects, they do not wither, but do not grow very well either. The plant monster illustrated here is created from the idea of starving insectivorous plants that suck human blood. Human blood tastes better than animals' blood because it contains more nutrition than that of small animals. The plants become addicted to the blood once they taste it. Soon they cannot resist their thirst for it and start to move out of the soil to look for human beings.

○ insectivorous plant x octopus x earthworm

☆ slimy texture

❏ This insectivorous plant has sucked human blood and cannot forget its taste. It has become so addicted to it that it has transformed itself into a monster. The character illustrated here is a ruined insectivorous plant, which strolls around to search for human blood. When it finds prey, it binds it up with its long tongue and brings it up to its mouth. It moves slowly and spits out mist to paralyze the quick and small animals. When it eats a human being, it stops moving to be able to taste and digest it well. It takes about ten days before the digestion is completed, and then it starts to move again.

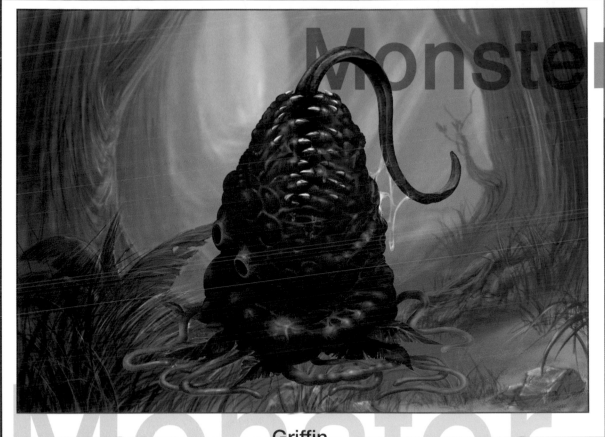

Griffin

It basically wraps its body around with its tongue and swallows its prey. It can grow to sixteen feet.

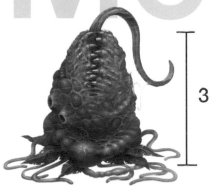

3-16ft

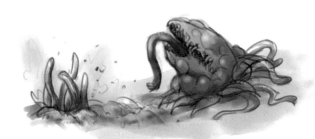

It attacks with roots from the ground.

A simulated griffin monster also exists inside its body.

It spits out mist to paralyze other creatures.

Fearful Monsters that Break the Laws of Ecology 2

❙ Reversed Survival: Bird-attacking Fish

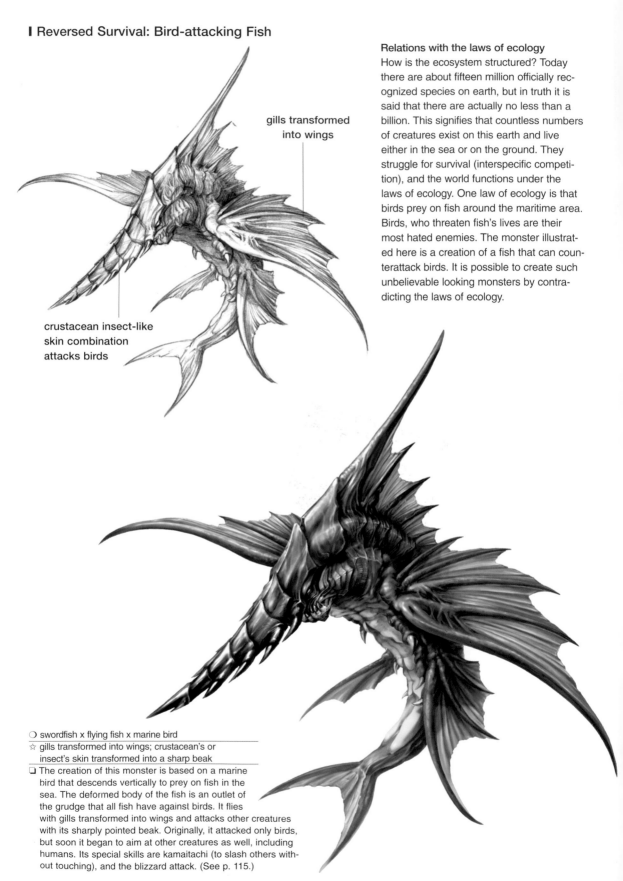

gills transformed
into wings

crustacean insect-like
skin combination
attacks birds

Relations with the laws of ecology

How is the ecosystem structured? Today there are about fifteen million officially recognized species on earth, but in truth it is said that there are actually no less than a billion. This signifies that countless numbers of creatures exist on this earth and live either in the sea or on the ground. They struggle for survival (interspecific competition), and the world functions under the laws of ecology. One law of ecology is that birds prey on fish around the maritime area. Birds, who threaten fish's lives are their most hated enemies. The monster illustrated here is a creation of a fish that can counterattack birds. It is possible to create such unbelievable looking monsters by contradicting the laws of ecology.

○ swordfish x flying fish x marine bird

☆ gills transformed into wings; crustacean's or insect's skin transformed into a sharp beak

❑ The creation of this monster is based on a marine bird that descends vertically to prey on fish in the sea. The deformed body of the fish is an outlet of the grudge that all fish have against birds. It flies with gills transformed into wings and attacks other creatures with its sharply pointed beak. Originally, it attacked only birds, but soon it began to aim at other creatures as well, including humans. Its special skills are kamaitachi (to slash others without touching), and the blizzard attack. (See p. 115.)

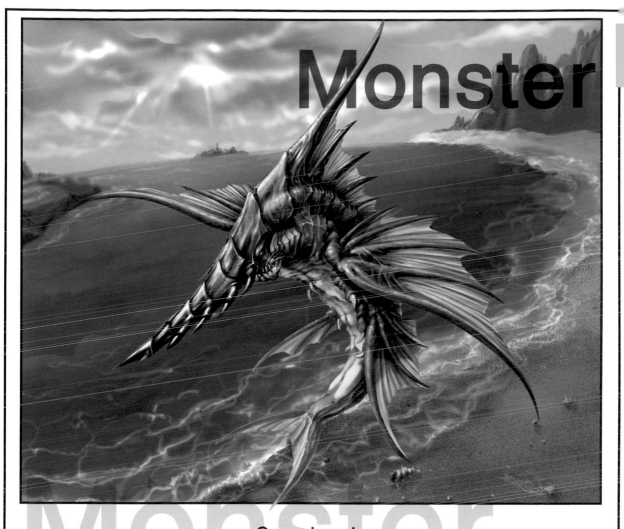

Monster

Spearhead

7ft

This monster is
unbelievably
seven feet long.

Kamaitachi
The monster creates wind to
produce a vacuum wave for
slashing the body.

When its beak breaks,
it starts a blizzard attack.

Head close-up
look of a broken beak

Spin attack
It spins down from the air to
attack another creature's head.

Ice eye
It blows out cold air from the
eye on its forehead to freeze
other creatures.

▌Hunters and Manipulators

One might imagine an era when human beings and monsters, such as harmless herbivorous dragons or defensive violent aliens, would live together. Perhaps one day human beings would try to capture and manipulate them.

Geo

He invents various weapons to capture monsters that commit evil deeds in the city and fills his house with them.

Malou

She is Geo's partner who holds a pair of popular throwing rings from the city called "free soops." She competes with Geo on who can catch the monsters first.

Lili

She is Dollarfrog's daughter and can manipulate fire aliens at her own will. She is also a meddlesome tomboy who loves monsters.

Dollarfrog

He is the greedy and haughty president of the "Monster Problems Consulting Office" who can use magic to manipulate monsters.

CARRIER ASH

Tall Tales from Japanese Folklore

Many half-human characters and multiformed beasts appeared in Japanese folklore during ancient times. Some of these unique Japanese characters are featured here. You can easily imagine being in this dream world.

Mythical beasts

Mythical beasts are holy, mysterious and prophetic symbols of the good (auspices), such as kirin and hou-ou. Most were introduced to Japan from China.

■ **Blue dragon**

The Blue Dragon controls water and has the power to remove wickedness and bring fortune. Its figure is called a *kyuji*, meaning nine similarities, because it resembles the nine types of animals. (See p. 54). It lives in water, ascends to heaven during the vernal equinox (spring), then descends and hides in the abyss during the autumnal equinox (fall).

■ *Gembu* (occult soldier)

The *gembu* is described as a long-legged turtle with a snake twined around its body. It is the head of the crustaceans and insects and also the genius creature of the north. It is covered with a shell and has a strong defensive power.

■ *Karashishi* (lion)

The *karashishi* is drawn as an imaginary lion creature brought to Japan from China. Its eyes stare at others to keep evil spirits away. It is the king of the beasts both in the west and in the east and is an intelligent creature of the royal families.

Dragons, hou-ou, kirin, and turtles were considered to be the "four mythical beasts," and the heads of all the animals in the world.

■ *Hou-ou* (peacock-like bird)

The *hou-ou* resembles a kirin from the front and a deer from behind. It has a snake's head, turtle's back, swallow's chin, and chicken's beak, but the real *hou-ou* is like a peacock and a phoenix. *Hou* means male and *ou* means female. It lives in the phoenix tree, eats bamboo fruits, and drinks sweet water.

■ *Kirin* (Chinese giraffe)

This giraffe with horns has a deer's body, wolf's head, bull's tail, and a horse's legs. It is very gentle and hates to kill so much so it fears stepping on bugs or plants on the ground.

■ *Baku* (tapir)

This beast eats nightmares and has an elephant's nose, boar's tusks, rhinoceros' eyes, bull's tail, and tiger's legs. During the Edo period, it was popular to sleep on a talisman with the baku's picture under the pillow. The shogun slept with it at his bedside.

Goblins

Goblins are personified figures of evil spirits that create mysterious phenomena beyond human understanding.

■ *Tengu* (long-nosed goblin)

This goblin has a long nose, ruddy face, long nails, and wings and lives deep in the mountains. Its costume resembles that of a Japanese mountain ascetic, with high Japanese wooden clogs, a sword around its waist, and a feathered fan in its hand. It uses magical powers and can fly. Sometimes it hinders the beliefs of Buddhism. *Dai-tengu* is one of the tengu goblins that possesses absolute magical powers, and *karasu-tengu* has a bird's beak.

■ *Neko-mata* (split-tailed cat)

This cat turned into a goblin after accumulating psychic power. *Neko-mata* refers to its tail split into two. It could sustain a long life in order to become a goblin. Some stories depict it disguised as a human being and eating people.

■ *Yuki-onna* (snow lady)

This is a beautiful woman dressed in a white kimono who appears in the legends of snowy countries. She is a reincarnation of the snow spirit. Her body is as cold as snow. People who get close to her lose their heat and freeze to death.

These are the *yamauba*, *tengu*, *kappa*, *yuki-onna*, and *zashiki-warashi*.

■ *Kappa* (river elf)

The river elf lives in waters or swamps, has a pointed beak, a turtle's shell, scaly skin, three-fingered webbed hands and a plate on its head to hold water. It dies without water on the plate. There are stories about the kappa challenging humans to a sumo bout, pulling them or horses down into ponds, or helping them with rice planting. It is a deformed figure or a medium of the water god.

■ *Zashiki-warashi* (tatami room child)

This child appears in the Japanese-style guest room of old houses in Tohoku, Japan and is said to guard the house's prosperity. He has a ruddy face and a bobbed haircut. He brings prosperity to homes where he settles. But he takes it away when he leaves.

■ *Yamauba* (mountain witch)

This female monster is tall with long hair, a big mouth, sharp glittering eyes, and lives deep in the mountains. She scares people with her eccentric laughter. She kidnaps and eats children from the village.

Gods of happiness

Immersed with the indigenous religions to bring people good luck or grace, these gods are the *dharma* (legless figurine), *manuki-neko* (fortune-beckoning cat),

fukusuke (large-headed dwarf), *Shichifukujin* (Seven Gods of Fortune), and others.

■ *Dharma* (legless figurine)

This ornamental doll is a bonze without arms or legs and wears a red robe. Zen patriarch Bodhidharma proclaimed, "seven falls and eight rises," which means, "When you fall, get up and start from the beginning." When the doll is knocked down, it sits up immediately. Its eyebrows represent cranes and its mustache represents a turtle.

■ *Manuki-neko* (fortune-beckoning cat)

This divine beast is a cat that beckons with its right paw to invite luck for money and its left paw to invite luck for customers. It first appeared during the Edo period and was displayed in storefronts and restaurants.

❙ Demons

In many folklore stories, demons or ogres are described as monsters that attack human beings. But this ogre is warm-hearted. It tries to shelter a woman and her baby who have run away from home because the woman's husband committed treason. In the Edo period, the wife and children of a man convicted of treason were executed. This woman hopes to save her baby no matter what may happen to her.

Character creation

Tengu
Design based on the image of a *tengu*

- ○ girl x *tengu*
- ☆ Japanese mountain ascetic's attire, *tengu* mask, wrap cloth
- ❏ The character is based on the image of a *tengu*. She is an advocate of justice and can manipulate the wind at her own will using her magical powers. She can fly freely into the sky by spreading her wrap cloth and can create a blast with her fan to blow away enemies. *Shishimai* is one of her partners. She infiltrates the enemy's hideout and fights with *Shishimai*.

Shishimai (lion's mask dance)
Design based on the *shishimai* tradition

In China, *shishimai* is an important custom. The custom is to wear a lion's mask. This dance is performed during the New Year's holidays in Japan as well, to wish for a secure life, rich harvest, good health, and to exorcize evil spirits. The character has a crimson face and puts on an arabesque-patterned cloak. Its eyeballs have the power to drive away evil spirits.

- ○ *shishimai* x police from the Edo period
- ☆ *shishimai* attire, police equipment
- ❏ This policeman fights against evil and advocates justice. When he finds an evil person, he rushes to defeat him. If he stares at people with his sharp eyes, they cannot move and are caught immediately. Sometimes, he commits dangerous actions.

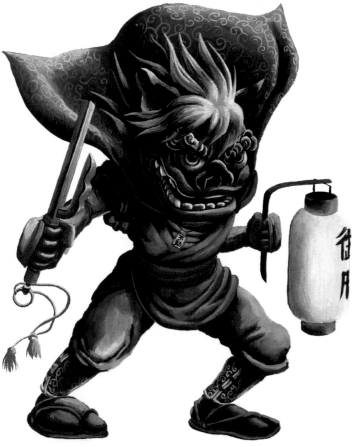

Dharma
Design based on the *dharma* doll

○ *dharma* x human being

☆ The original dharma doll wears a red robe, but this character wears a robe in clashing colors of yellow and blue, because it is an evil character. It also wears a sacred shrine rope as a belt around its waist and holds swords in each hand.

❏ This character is an evil assassin who is a master in using swords in each hand. He has a sharp mind, acts quickly, but is vulnerable to alcohol. The *shishi* or lion on the previous page is his natural enemy, and they always chase after each other.

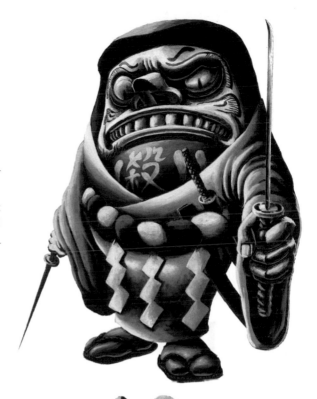

Neko-mata and Manuki-neko
Design based on the image of the *neko-mata* and the *manuki-neko*

○ *neko-mata* x *manuki-neko* x harlot

☆ harlot's attire

❏ This cat character is disguised as a harlot who deceives and enchants men to control them at her own will. She controls the men secretly, and she never acts on her own.

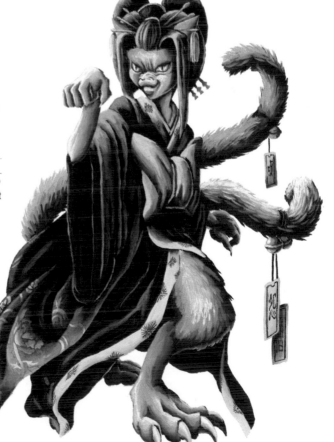

Creation of Wind and Thunder Gods

| *Hujin* (wind god) and
| *Raijin* (thunder god)
The apotheosized figures of the wind and thunder originated from ancient Japanese times and are the gods for a rich harvest and prevention of sea disasters.

The wind god creates the wind, and people pray to him to calm it. The thunder god creates thunder and rain, and people pray to him for rain. People pray to both gods for a rich harvest. Both gods originated from the gods of Brahmanism in Buddhism and came to Japan with the Buddhist religion. They were fused with the folk religions for nature worship.

Basic form of the wind god It has a figure of a red ogre that runs around the sky carrying a wind bag on his shoulder. It has four fingers that point to the east, west, south, and north, and two toe digits.

Basic form of the thunder god It has a figure of a blue ogre that runs around the sky carrying multiple drums on his shoulder. He has three fingers that point to the past, present, and future and two toe digits.

Representations in Japanese paintings Since Buddhism was introduced in Japan, the wind and thunder gods have often been used as subjects in the world of paintings. In Korin Ogata's *Painting of the Wind and Thunder Gods on Paper with Gold* and Sotatsu Tawaraya's *Painting of the Wind and Thunder Gods on Folding Screen*, which are both Japanese national treasures, both gods are shown with five fingers. The Japanese images of the wind and thunder gods are formed as they are drawn, departing from the basic forms.

Free Creation from the Basic Form
Study 1
The wind god has three horns, while the thunder god has four. Both gods are small, and have five fingers, and three toe digits. The wind god's body's color is green, and the thunder god's color is white.

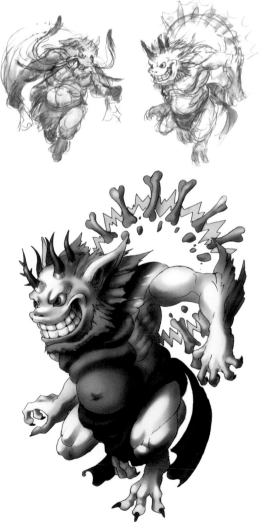

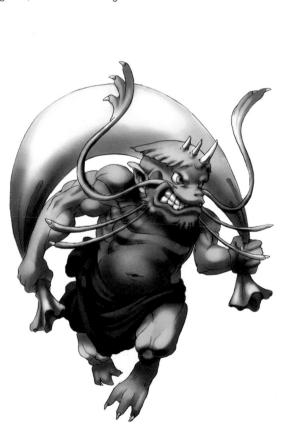

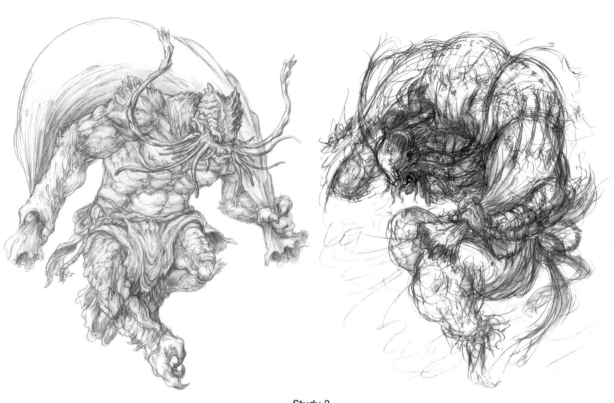

Study 2
Drawing a rough draft to study the pose and direction of the body

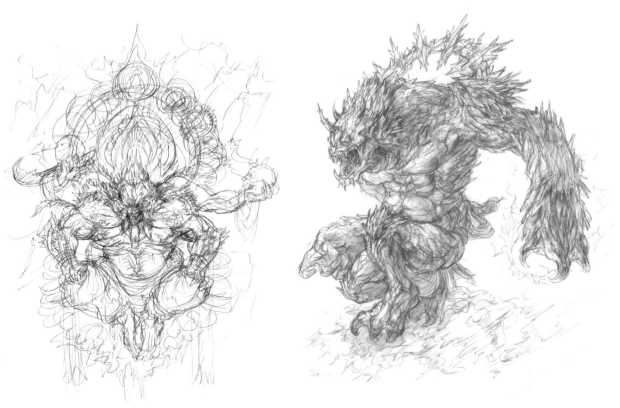

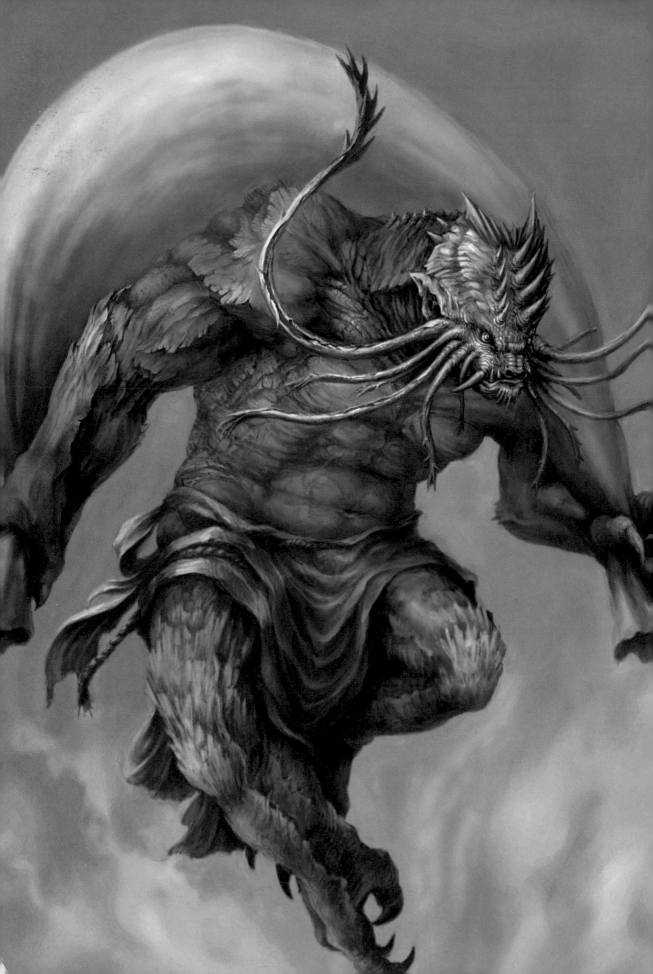

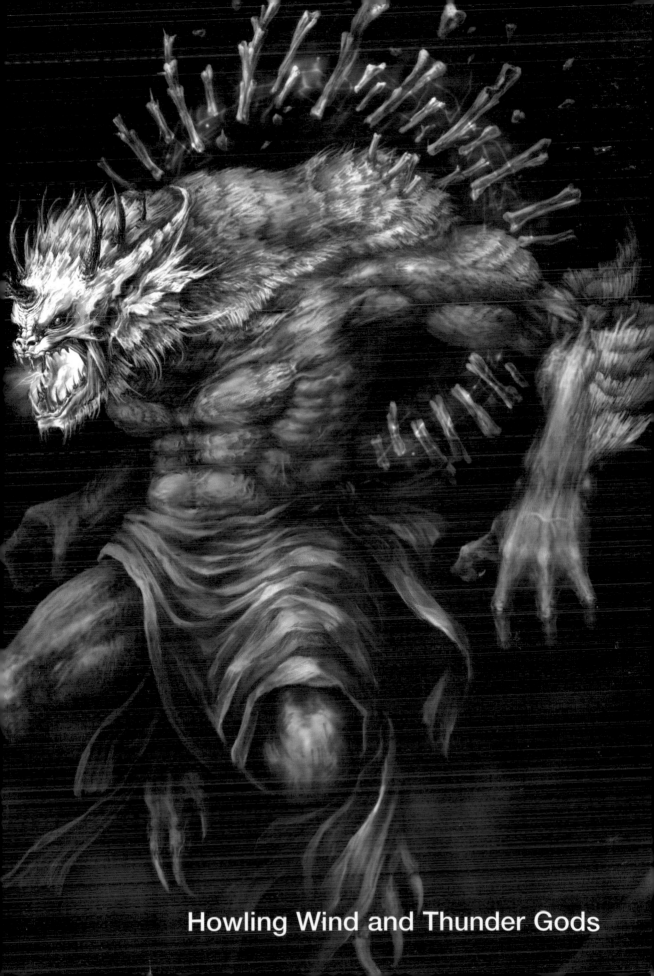

Howling Wind and Thunder Gods

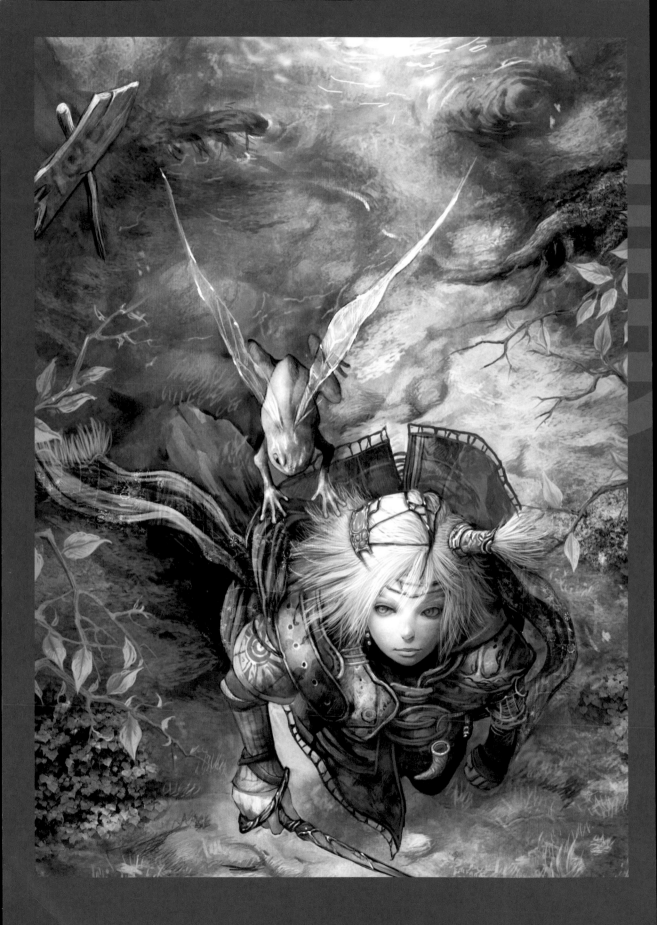

World of
Fantasy Characters

Devil's Den:
Ten Thousand Devil Masters ("Pandemonium")

The word "pandemonium" is taken from the Greek phrase "all of demons," and was used by John Milton, author of "Paradise Lost." It refers to the infernal city, which houses the castle of Satan and the other fallen angels.

John Milton was a 17th-century English classical poet who wrote the epic poem "Paradise Lost,"* one of the most eminent works in English literature. Milton used Satan, who fell from Heaven, and other devils as characters in his work. Many of the characters originated from the Bible, but Milton also imported demonology and classical folklore as extensions of biblical interpretation, as well as the gods of pagan religions that were demonized by the Christians. He introduced these fallen angels in his own way. "Paradise Lost" has become famous, and is now widely read all over the world, especially for the scene of the "pandemonium," which has eventually become the standard setting of fantasy fictions today.
What types of demons in pandemonium can be used for one's creation?

Pandemonium in today's fantasy fictions appears as:
1. a temple where fallen angels, devils, and monsters live
2. a devils' den where conspiracies and crimes are committed

* Paradise Lost = John Milton's epic poem published in 1667, consisting of 10,000 lines, and based on the Book of Genesis; Milton wrote about the fall of man, Satan's rebellion against God, and God's grace.

Egg Guardian

Two Holy Beast Egg Guardians

Two holy beasts live in a deep forest and are in danger of extinction. Both were born with the mission to guard their eggs and the great forest at the same time.

GROVE VIOLATER

Female Monster Fighters These female fighters defeat monsters endlessly. Their real enemy is the unknown person who transforms living creatures into monsters. They pray for their souls.

Meeting the Strongest Dinosaur

These dinosaur-breeders are a brother and sister who hunt for an amazingly strong dinosaur. They want to breed the strongest dinosaur in the world.

Pose with the Beaten-up Dragon This figure poses with the beaten-up dragon while having lunch.

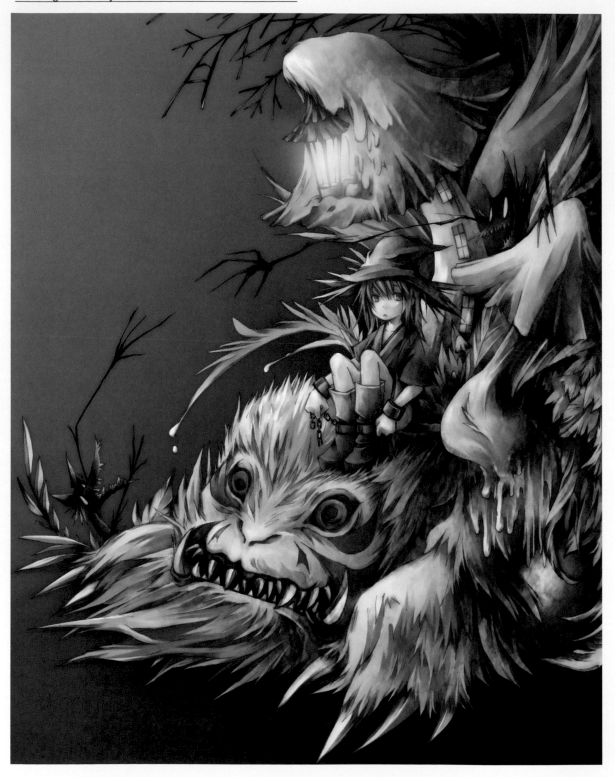

Clone Child and Multiformed Beast

A clone child is abandoned after he was created. Shown here with a multiformed beast, he lives but never moves, just like an ornament. He grows plants from his body and waits for a master who can take care of him.

Clone Child and Kind, Low-ranking Soldier

The soldiers have caught a clone child, and they lock him up in a cage to sell him. However, one kind soldier packs food in a bag and gives it to the child.

Girl Traveling
with a Multiformed Beast

In the world of human beings, half-human creatures and multiformed beasts, a girl lives in a decaying town controlled by high society, but travels with a multiformed beast to search for a more ideal world.

Master Ventriloquist A ventriloquist ghost attacks human beings using his doll to eat them up and to feed himself. Following his nocturnal habit, he appears in the village during a full moon.

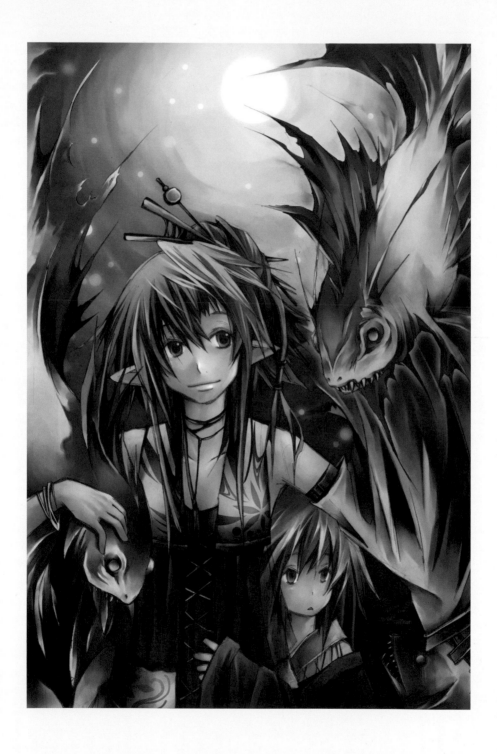

Living with Goldfish 1 Flying goldfish enter the village in this imaginary world.
The illustration captures the loving and understanding
villagers' relations with the goldfish.

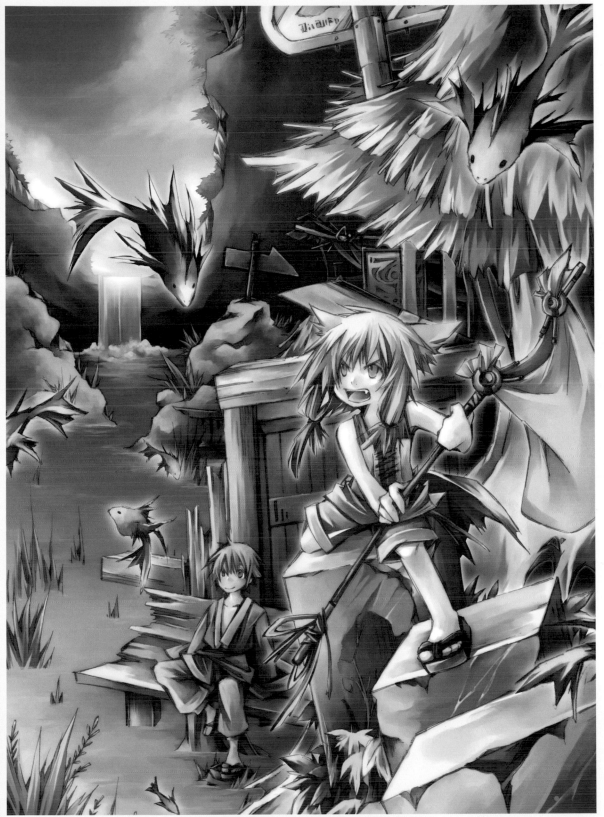

Living with Goldfish 2 In contrast to the previous imaginary world, a child tries to drive the goldfish away, and a young man sits back and watches the scene. This picture and the one on the opposite page question whether human beings can live together with multiformed beasts.

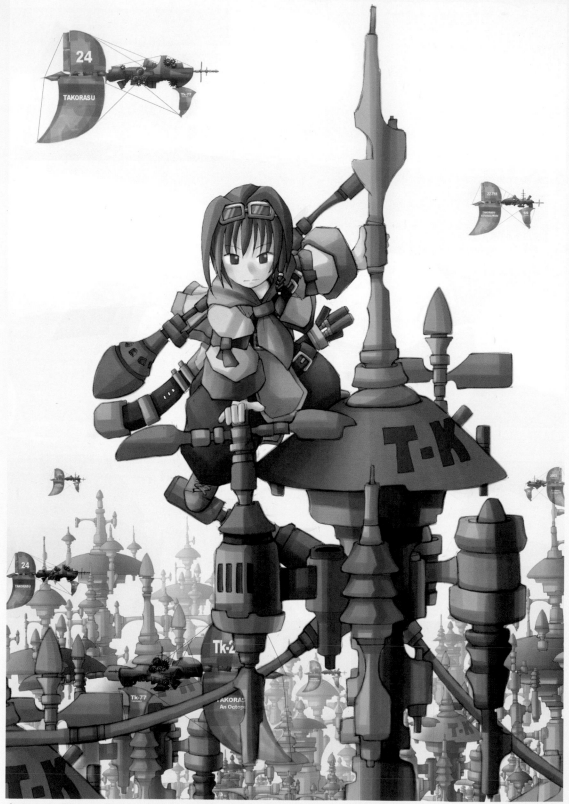

Antenna Repair Boy The future world is cramped with antennae, and the antenna-repair boy is immensely busy every day.

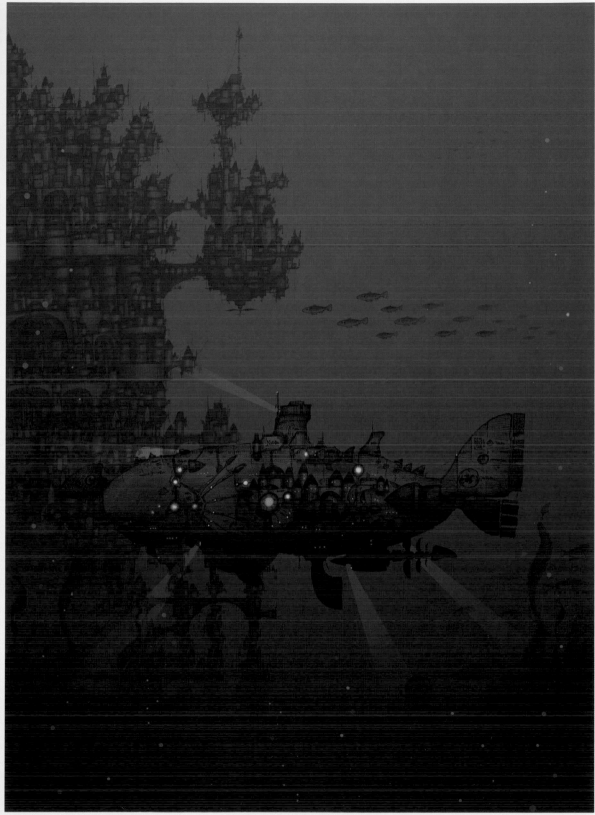

Artificial City in the Deep Sea In the world of the future, human beings build a city under the deep sea. A whale-shaped submarine patrols the sea.

Stories from Characters

1. Origin of Monster Tales

The story illustrated here comes from a small village called Goschenen in Switzerland and has been handed down for generations. It outlines the origin of Frankenstein's monster and claims to be the original source of his monster.

1. Once upon a time, there were ranchers who lived free-spiritedly in a stock farm in Goschenen.

2. The ranchers were tired of just looking after their livestock everyday. Hence, they made a doll out of a piece of rug to escape from their boredom and reduce their stress.

The badly abused doll transforms into a monster.

3. They gave the doll a terrible name and blew off steam by hitting and kicking it. One day, one of the ranchers mischievously baptized the doll, and to his surprise, the doll started to speak. The ranchers were shocked at first, but then continued to beat it. They could not stop abusing the doll, and the violence grew worse. The badly abused doll developed a grudge against the ranchers, and soon, it turned into a fearful monster and killed one of the ranchers. Since then, the monster doll owned the farm and it was never again inhabited.

The reason this old story had been handed down for generations and became the original idea for Frankenstein's monster is because it tells us a human truth. Fairy tales, myths, and folklores teach moral values that last more than a hundred years. People identify with this story and remember it for many years. They are moved by the human truth and share a common sorrow with the monster doll that they can pass on to others. What is the essence of this story?

Through the symbol of the doll, this story allegorically represents human beings who do not desire to be born or are unable to choose their birth environment. Nevertheless, they survive regardless of their ill-chosen surroundings. Human characteristics vary greatly depending on where one is born.

If the ranchers had treated the doll more kindly, the doll would not have had to turn itself into a monster and may have even served the ranchers. The story demonstrates the sorrowful birth of the monster created by the cruel human mind. We remember the words of Frankenstein, "Why do I have a human mind, and not a monster's mind in a monster's body?"

Possible Sequel to the Story

You can imagine a sequel to this story to create other various episodes.

The doll began to speak after being baptized. It was repeatedly and badly abused by the ranchers that it turned into a fearful monster and killed one of them. Afterwards, the monster owned the stock farm and no one ever lived in it. After several years...

Sequel 1. The child of the murdered rancher develops vengeance against the monster.

Sequel 2. The other ranchers go to the priest to seek advice.
The priest tries to revert the doll's baptismal rite to return it to its original state.

Sequel 3. People who did not hear of the rumor about the monster's tale buy the stock farm and begin to live there.

Alternative to sequel 1

The child of the murdered rancher hires three warriors to execute the vengeance for the sake of his murdered father: a witch, strategist, and someone with a Herculean power.

It is also possible to create another story by changing the original theme, such as altering the situations, time, and the country setting.

Example: Future suspense story
Workers abuse defective robots in a factory, and the robots gain intelligence, but go berserk.

2. Adventures of the Ash-covered Princess Spaceship

This story is created based on the relations among atrocious monsters. The scene is set in the future where team members are selected to board the Ash-covered Princess Spaceship. Their mission: to patrol for and pacify the atrocious monsters that act ruthlessly on the planet.

Mobile planet "Uhai"

Due to a domestic battle that occurred 5,000 years ago, most of the human beings from this planet move to other planets.

Atrocious monsters

The planetary mainte- nance system has sucked up the life energy of these deformed crea- tures. They can no longer choose their enemies.

This small space- ship was built for the cosmic patrol force team to undertake a plane- tary ecological investigation.

Ash-covered Princess Spaceship

First city

This is the only city of inhabi- tants that has remained on the planet.

Daniel
He is the only person whose atomic structure can be destroyed when touched. However, the earth's government organ- ization can reconstruct it instantly using genetic modification. Daniel is a highly skilled doctor, and was designated to be on board the spaceship for only a limited period of time.

Aruha Kyariko
She appears in the spaceship, asking the force team to take care of the planet. Then she guides them to the central plan- et Uhai.

3. Boundary Sky

This story is an imaginary vision of the world where human beings, half-human characters, and multi-formed beasts live together.

In this world, a hierarchical system is deeply rooted in society, with the divinity at the top. The main character, Ira Falk, is the son of impoverished and aristocratic parents. He journeys in search of freedom. He encounters acquaintances and builds true friendships with them.

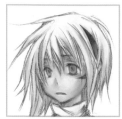

Ira Falk
On his journey

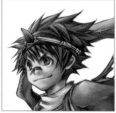

Ishka Hulsfeel
Emperor's son

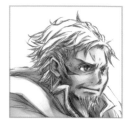

Shest Hulsfeel
Emperor

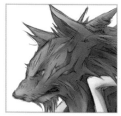

Crome Shester
Doctor who serves the Imperial family

Enji Seki
Traveler

Uzuki
Acquires the job of hunting for stateless people

Minatsuki
Uzuki's younger blind sister

Kinua
Enji's nephew

YOU
Wandering slave

YOU
Stateless person who lives in the slums

YOU
Penniless person looking for a home

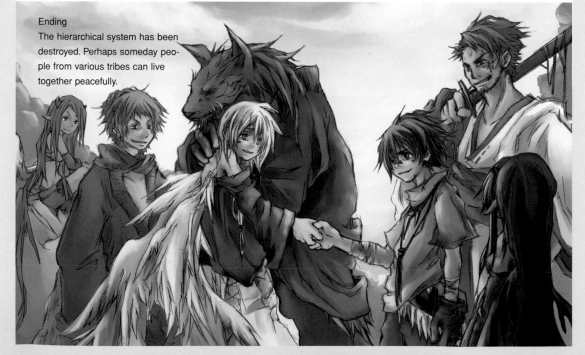

Ending
The hierarchical system has been destroyed. Perhaps someday people from various tribes can live together peacefully.

4. Wingless: Angels Without Wings

This story consists of imaginary angels created by combining parts as introduced on p. 24.

Story

A prophet once said, "Countless numbers of angels will fall down from the sky and will bring forth a miracle to everyone. Eternal happiness will be promised to anyone who follows them." Many events started to occur in the prophecy's name as humans and angels began to live together. Five years have passed, and now the human capital is completely ruled by angels.

Chapter I. Main character's village
1. The village of Mizu, the main character, is attacked by the celestial group headed by Tizma.
2. Mizu's foster father, Saiga, is missing.
3. Mizu encounters Saiga's old friend, Rogue. They go to the capital city ruled by the celestial people.

Chapter II. Capital city
1. Mizu encounters Auma and Patos, who are hostile to the celestial people, and enters the capital city with their cooperation.
2. He discovers the capital city's existence and the celestial people's empire in the sky.
3. He attacks the convoy that ships out humans to the capital city. However, the rescued people resist being saved because they worship the celestial people. Consequently, the operation fails.
4. Mizu rescues Auma's daughter, Nikka, and finds out that the believers are brainwashed.

Chapter III. Journey to the Sky
1. Mizu attacks the convoy again, and his team obtains a vehicle. One of the celestial people, Kyoka, joins Mizu's team and becomes their friend.
2. Mizu attacks the floating islands around the capital city.
3. He reaches one of the floating islands called "Prison Island" and brainwashes the dangerous people who are apathetic to the angelic religion.
4. He rescues Saiga, and discovers that he is one of the celestial people.
5. The brainwashed prisoners who become believers commit suicide.

Chapter IV. Imperial city
1. Mizu defeats Emperor Ulzast.
2. Tizma steals the Emperor's wings and reveals to Mizu that he is his older brother. He also confesses that he stole Mizu's wings when he was born.
3. Mizu is dropped into the sea.

Chapter V. Sea treasures
1. Traces of human culture are found at the bottom of the sea.
2. A huge mass of magic stones are also found.
3. Mizu returns to the earth.
4. Tizma senses the existence of the magic stone.

Final Chapter
1. Final battle
2. The magic power obtained from the bottom of the sea removes the brainwashing performed on the believers.

Expression of Humanlike Emotions

Ultimate Lives Borne from Human Ego

Who could be the most frightening creatures in this world apart from deformed monsters? The answer is human beings. Since human beings possess emotions that no other creature has, their internal minds consist of complexly intertwined and unlimited desires. The monster illustrated on the opposite page is a ruined figure of a human being who has lost its reasoning power and who is ruled by negative desires absorbed from the entire world-combined into one deformed body.

Joy

Human beings are the only living creatures who can be ecstatic with joy.

If we were to classify the desires that intertwine inside the human mind, there would be three different types: need, impulse, and desire. According to Sigmund Freud, the patriarch of psychoanalysis, "humans are controlled by unconsciousness." In other words, the inner behavior that human beings are aware of, or are able to control-that is, consciousness-is only the tip of the iceberg. Most parts of the human mind form unconscious behavior, which human beings cannot know of or cannot have control over; thus, they are controlled by "impulses" that arise from the unconsciousness.

First Classification: Need
Need refers to something instinctive that is inherent in both human beings and other living creatures. It includes the basic desires necessary to survive biologically, such as the desire to eat or sleep.

Second Classification: Impulse
Impulse refers to the unconscious urge that constantly drives humans to act. According to Freud, most parts of the human mind are placed under the impulse control. Humans' unconscious desires or impulses vary from age to age. For example, a new born baby desires mother's milk, and a three-year old child desires food to eat. Love is desired unconsciously from birth until death. Personality is mostly determined by satisfied or dissatisfied impulses during infancy. If one does not satisfy one's impulses during adulthood, he or she may end up having a perversion, such as sadism or masochism.

Third Classification: Desire
Desire is the emotion stimulated by one's wish to obtain something. It refers to strong feelings of demand or the wish to gain something that is lacking. The desire to be beautiful or smart, to be with someone, to love, or to be loved are emotions that are unique to human beings and arise from unsatisfied impulses.

Inside the human mind, countless needs and desires exist in multi-layers, intermingling in a complex structure and swirling around in chaos. To exist positively, or to be transformed into a vicious monster, can only be defined by one's own mind.

Monster creation 1: "Featherarm"
The monster character illustrated on the opposite page is created out of the energy of human emotion that changes, wanders, suffers, and struggles. He throws himself into darkness and shuts himself by covering his entire body with countless feather-like hands. His main body appears as though his hands and nails are transformed into knives and swords, which can slash anyone mercilessly. He does not have any particular weakness and appears chaotic. His actual form is unknown.

When one is psychologically attacked by monsters, one must escape without thinking. He/she should concentrate on running away from the monster, telling oneself, "This monster doesn't exist!" By doing so, he/she can succeed in concluding that the vision is just a nightmare.

Sigmund Freud (1856-1939)
Austrian psychiatrist and founder of psychoanalysis, he started his own treatment for neurosis based on the free association method, and established psychoanalysis to concentrate on unconscious thoughts and sexual impulses. His ideas greatly influenced literature, art, and other fields of study. In 1938, he fled to London to escape from Nazi persecution. His major works are: *The Interpretation of Dreams, Introductory Lectures on Psychoanalysis*, and more.

Insanity

Monster creation 2: Deformed snake woman

Ayantesca is the fictional name of an ancient city that is inhabited by people who appear to live peaceful lives. However, behind the calm, oracles exist who govern the city and summon children born in a particular year to go to the temple, where an old ritual is executed to check their idiosyncrasies. A strange disease had been spreading since people settled in this land. In the past, their lives were threatened several times due to this disease. The bodies of the children who were born in a special year-that occurs once in a few hundred years-saved the people's lives.

The oracles raised these children until they reached the age of about eighteen to twenty, then deformed them into monsters using a secret magic handed down to them through an ancient legend. When the children were treated with this magic, the skin on their backs began to peel, like scales from spots, and transformed their bodies into snake-like figures, covering their heads and upper bodies for five minutes or less. People who suffered from the strange disease and ate the flesh recovered in three days. These monster children were called "children of the snake god" and were believed to have been born with the destiny of being sacrificed. However, children who were not treated with the secret magic were never deformed into monsters during their entire lives. The monsters of this world were created from the people's impulse to stay alive.

Monster creation 3: Deformed vampire after blood-sucking

In the following spread on pages 162-163, a man is transformed into a vampire after another vampire has sucked his blood. His body gradually deforms and changes into a completely different figure from that of a human being. He develops a desire to attack humans in order to suck their blood. Unlike human beings, vampires do not die completely. They live as directed by their impulses, and can remain as vampires forever. However, this creature has a strong reason to return to his original state. Although his body is transformed into a monster, he still wants to keep his human mind. Nonetheless, his ironic fate is that his girlfriend is a descendant of a strict vampire family. Not knowing anything about this creature, the woman is ordered on a mission to stalk him. The monster suffers from the sorrow of being chased by his only beloved and the pain of controlling the vampire's impulses. Tonight, he finally transforms into a complete vampire.

Love

Human beings are the only living creatures who know about love.

Human beings possess desires that no other creatures have, and they end up producing the most fearful and sorrowful monsters in the world. At the same time, a positive emotional energy, love, exists among their desires, and it create the most beautiful spirit.

Love refers to:

1. a moving mind that recognizes a precious target, which one becomes attracted to; or an expression of such a feeling.
 (a) a mind that cherishes other creatures or objects and wishes good things for them
 (b) a longing emotion for the opposite sex, such as an amorous feeling
 (c) a feeling toward someone or something that is stronger than any other emotion

2. God's unlimited and deep affection toward human beings as taught in Christianity is based on the Greek term, "agape," which refers to Christian love: God's love toward sinful humans, human fraternity, self-sacrifice, and uncalculated love, as distinguished from eros.

3. an act of being caught by someone or something, and of being obsessed with it, as taught in Buddhism-a desperate demand, such as thirst.

4. a behavioral appearance that gives other people a good impression, such as sociability or amiability.

Spirit creation: Elf — the love spirit
The elf is the spirit of love that embodies human maternal love and cherishes all elements that exist in the natural world. It differs from the fairy since it is more powerful and resembles human beings more closely. Fairies bear love for individual elements of nature, such as a flower, leaf, drop of water, or the sunlight passing through the trees. On the other hand, the beautiful spirit illustrated on the opposite page is born from the love that exists for the entire natural world.

It exists wherever people are. It may not be seen, but it can be felt. One has surely experienced sensing certain normal things that looked different, or has felt special and affectionate emotions toward something or someone. The spirit has the ability to sow the seeds of love and to make them sprout.

It does not necessarily avoid dialogues with human beings. One who needs the spirit's help must keep their five senses sharp and acquire the ability to correspond with it by training one's body and mind. This spirit joins other spirits in helping those who have called it. However, it also possesses a defective trait. It is so pure that it tries to realize everything a person desires regardless of good or bad effects.

People who communicate with the spirit sometimes become greedy. In such a case, the spirit can kill itself together with the person. It may appear dull, but it expresses its love in this manner.

Appendix: Form Matrix

Combinations of animal bodies and parts often used in character creation

Type x Type (link → p. 166)

Form Table		Human being	Doll	Mammal	Fowl	Reptile	Amphibian	Fish	Insect	Plant	Machine	Building	Tool	Other elements
Fixed form	Human being													
Non-fixed form	Doll													
Collective form	Mammal													
	Fowl													
Mechanical form	Reptile													
Cracked form	Amphibian													
	Fish													
Increase/decrease	Insect													
Length span	Plant													
Growth	Machine													
	Building													
Combination	Tool													
	Other elements													

Free Creation

Frog's body used as base structure

I Human amphibian

	Human being	Doll	Mammal	Fowl	Reptile	Amphibian
Human being						○
Doll						
Mammal						
Fowl						
Reptile						
Amphibian						

○ frog x soldier

☆ coat, spear, nose ring

❏ This creature is a middle-ranking soldier of the water territory. It is brave and fights without fear. When it comes to battle, it is most powerful in water, but is weak against fire.

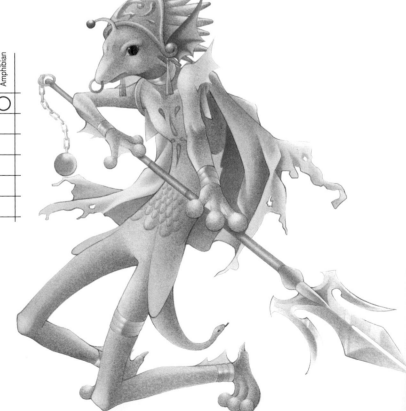

Form Matrix
Combinations of animal bodies and parts often used in character creation

Type + Parts (link → p. 168)

Form Table	Human being	Doll	Mammal	Fowl	Reptile	Amphibian	Fish	Insect	Plant	Machine	Building	Tool	Other elements
Fixed form													
Human being													
Non-fixed form													
Doll													
Collective form													
Mammal													
Fowl													
Mechanical form													
Reptile													
Cracked form													
Amphibian													
Fish													
Increase/decrease													
Insect													
Length span													
Plant													
Machine													
Growth													
Building													
Combination													
Tool													
Other elements													

Free Creation
Bee's wings grow from the back of the beautiful woman.

I Human bee

	Human being	Doll	Mammal	Fowl	Reptile	Amphibian
Human being						
Doll						
Mammal						
Fowl						
Reptile						
Amphibian						
Fish						
Insect	○					

○ beautiful woman + bee

☆ bee's body structure, suit design

❏ This queen bee is accompanied by more than a thousand human bee followers, and never forgives anyone who contradicts her orders. Those who do will instantly be attacked, killed and eaten up together with the other followers.

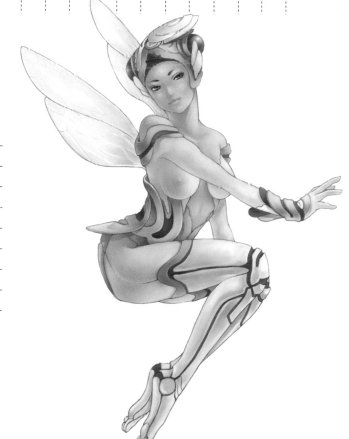

165

Type x Type (Animals often used in character design)

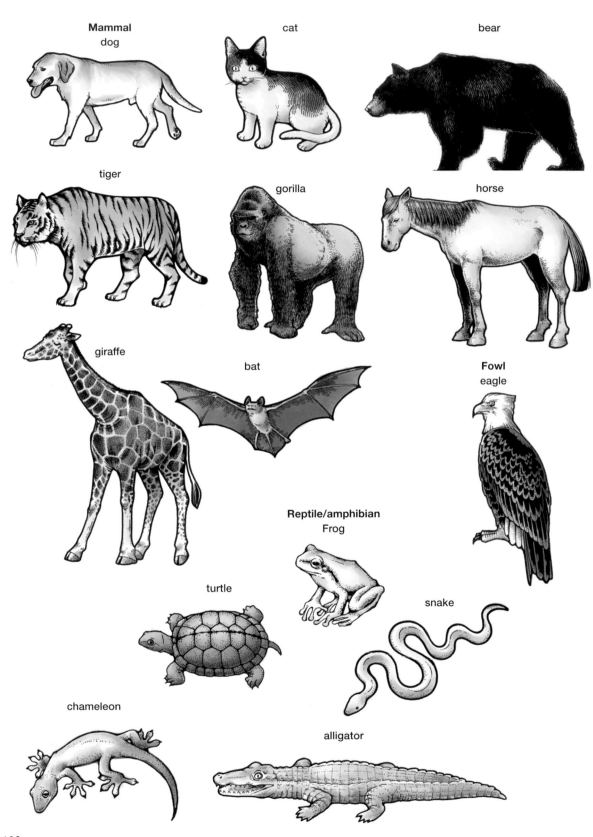

Mammal
dog

cat

bear

tiger

gorilla

horse

giraffe

bat

Fowl
eagle

Reptile/amphibian
Frog

turtle

snake

chameleon

alligator

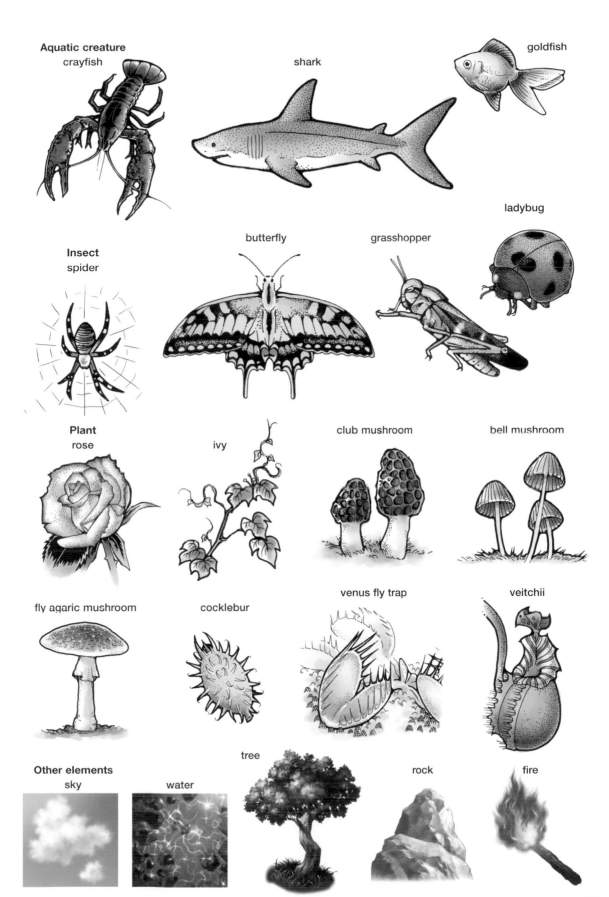

Aquatic creature
crayfish

shark

goldfish

ladybug

Insect
spider

butterfly

grasshopper

Plant
rose

ivy

club mushroom

bell mushroom

fly agaric mushroom

cocklebur

venus fly trap

veitchii

Other elements
sky

water

tree

rock

fire

Type + Parts (Parts often used in character design)

Horn
musk ox

Mediterranean mouflon

dall sheep

black rhinoceros

Japanese antelope

red deer

addax

Ear
bat

dog

cat

Eye
human being

frog

tiger

cat

snake

longheaded locust

wasp

damselfly

spider

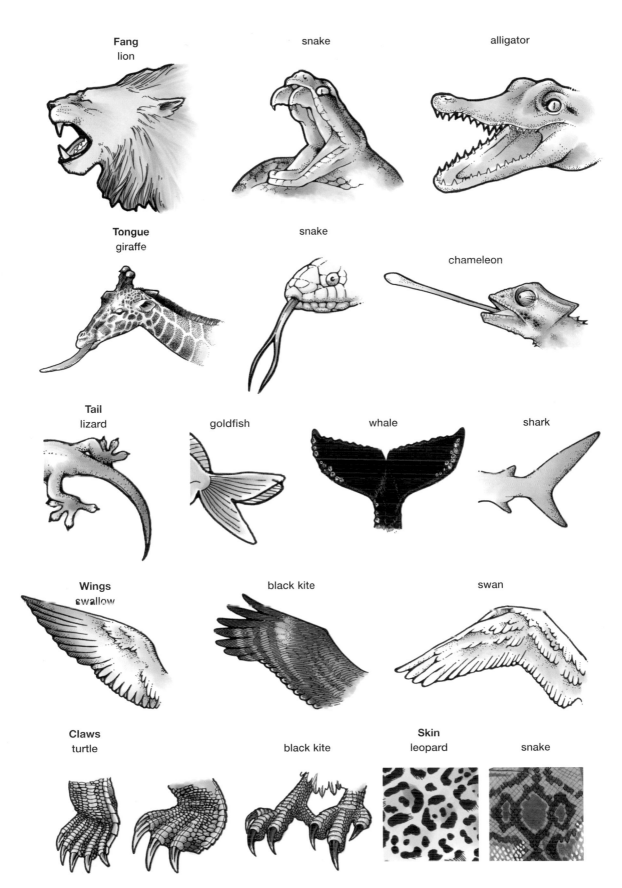

Fang
lion

snake

alligator

Tongue
giraffe

snake

chameleon

Tail
lizard

goldfish

whale

shark

Wings
swallow

black kite

swan

Claws
turtle

black kite

Skin
leopard

snake

Appendix: Costume Matrix-Mask

Dress-up Table

Body wear	Body wear	folk costume, uniform, dress, tuxedo, suit, leotard, swimwear
Covering/footwear	Covering/footwear	mask, eye patch, coif, hat, armor, cloak, glove, shoe, fur, glasses, sunglasses, tights
Ornament	Ornament	crown, collar, bracelet, ring, nose ring, anklet, pierced earring, necklace, jewel, ribbon, wound, skull
Makeup	Makeup	lipstick, eye shadow, mascara, manicure, tattoo
Wrap/tie	Wrap/Tie	bandage, cast, artificial leg, shawl, scarf, rope, chain, turban, bandana, ribbon
Carry-on item	Carry-on item	aarmor (shield, saber, sword, knife, bow, spear, gun, rope, ax, chain, bomb); musical instrument (Japanese koto, flute, ocarina, harmonica); medical instrument (syringe, stethoscope, scalpel, chart, medicine, crutch); stationery (pencil, eraser, ruler, compass, stapler); toy (doll, cards, magic kit); toiletry (compact, lipstick); witchcraft tool (cane, talisman, book); cookware (kitchen knife, frying pan, pot, dish, knife, fork); personal belonging (cigarette, umbrella, bag, cellular phone)

▌Creation of a personified caterpillar

Masks can offer various special effects to character design, such as transformation, virtual appearance, or mystery. One can design different mask shapes and put them on their created character.

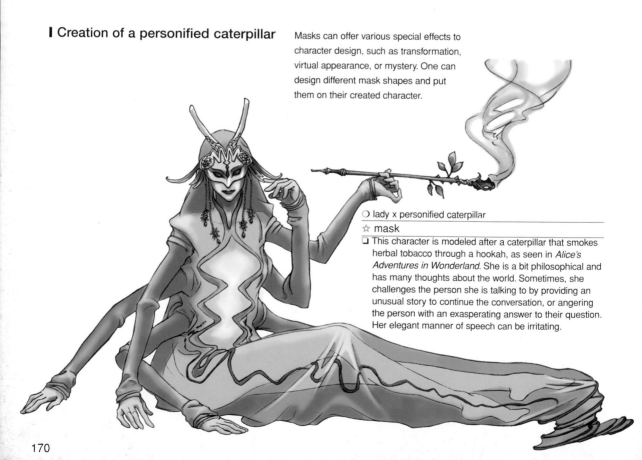

○ lady x personified caterpillar

☆ mask

❏ This character is modeled after a caterpillar that smokes herbal tobacco through a hookah, as seen in *Alice's Adventures in Wonderland*. She is a bit philosophical and has many thoughts about the world. Sometimes, she challenges the person she is talking to by providing an unusual story to continue the conversation, or angering the person with an exasperating answer to their question. Her elegant manner of speech can be irritating.

Afterword

For more than thirty years, I have been engaged in the education of art, design, animation, illustration, and character design, and now I often think of my students not as students, but rather as creators. To the professional's eyes, it may seem that they have a long way to go before becoming true designers, but I can find many talented students without judging their experience or technique.

When young talented creators work on character creation, they sometimes get stuck choosing from so many ideas. That is the exact moment when I want them to make the best use of the *Manga Matrix* book.

Many intellectuals in the world of art and design history have left behind creative ideas and methods for the present generation, which should be enough for us to learn how to express our own concepts.

For instance, I learned that the archaic smile in Greek sculptures from that period was applied to the Japanese robot character, *Ultraman*. Likewise, in ancient Greece, the methods of combining a human being and a horse for Centaur, or a human being and a bull for Minotaur, were also used for creating monsters. Baltan is created as a combination of a human being, cicada, and scissors.

Characters are created by this additive and subtractive method. Perhaps, it would be better if we could come up with attractive expressions that do not have to add or subtract elements to and from the original form, but that would be extremely difficult. Thus, this method has become convenient for character creation. However, this is only one technique for character design. Characters can also breathe the creators' inner desires.

A creator feels many things when designing characters, but for my own creations, desire is one of my motives. Other people have various desires as well; when they desire to love, they also wish to hate; when they desire to be lost, they crave to solve the problem; when they desire to destroy, they urge to create. My own desire for character creation is very simple. It comes from a world of imagination where I seek fun in seeing two or more characters as friends or partners. For example, I would feel awesome if I could control a gigantic robot, such as what Shotaro did in *Tetsujin 28* and *Astroboy*, the popular Japanese characters that I read when I was a little kid; or I would feel wonderful if there were three persons inside me who could help myself, like in Babel II, the renowned Japanese manga.

Most of the creators who have dedicated their efforts to this project are my former students. I asked them to draw new characters as current freelance creators or to add touches to their past sketches.

Finally, I gratefully acknowledge the contribution and support of all the other creators, Kayoko Miyamoto of the Editorial Department of Maar Publishing Company, and all the staff members.

Hiroyoshi Tsukamoto

Contributing Artists

Hiroyoshi Tsukamoto, Akiko Mizutani, HIRO, Wasabi, Hiromi Itoh, Yoshiyuki Hidaka, mutsumigen, Souta Kuwahara, Kituvame, Yuichi Eguchi, W Bowy, Natsuki Iwazawa, Miu Sasaki, Hidetoshi Nakajima, Ryoma Tsuchiya, Keiko Kadochi, Chikako Nakano, shishido, Saeko Kunimoto, Yuki Tsurushima, Naoki Makiyama, Kikuchi, fumiko, Hakukei, Tooko Yokomizo, Takako Sato, Miki Ogitsu, Yueri, TAKORASU, Ayumi Ikeda, matsumoto, ENOMOTO, Kochi, Creators Mei, Enpitsu Club, Akihisa Mayama, Maokoto Taichi, AYA

Author's Profile

Hiroyoshi Tsukamoto
Background in art and design education spanning over thirty years; continually struggles to train future creators

Publications
Kyaradezasumashu ("Character Design Smash"), Graphic-sha Publishing Co. Ltd.
Manga Baiburu 1-Hikari to Kage no Enshutsuhen ("Manga Bible 1-Light and Shadow Effects"), Maar Publishing Co.

Professional Background
National Cancer Center, Japan, Pediatrics Ward, wall art
Musical, "Bollocino," character, stage and costume design
Yokohama Emergency Center, exhibition illustration
Genshi Adbenkan ("Primitive Adventure Hall"), planning and storyboard
"Lego Land," campaign illustration
Sekai no Otogikan ("World Fairy Tale Hall"), planning and illustration
Nagoya Maritime Museum, character design and exhibition illustration
Nagoya Higashiyama Zoo, Children's Hall character design
"Kishin Shinoyama Silkroad," LD illustration
Japan Ministry of Construction, city creation book illustration
Tsukuba Science Expo, "Cosmo Technology Pavillion," character, logo and pamphlet design; "NTT Pavillion," image illustration
Andersen illustration and character design

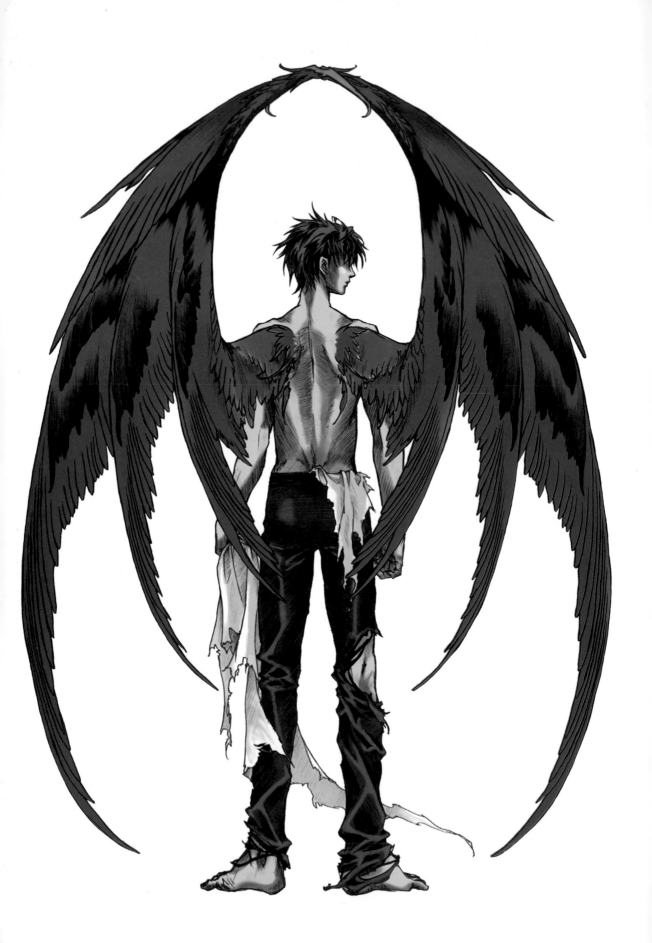